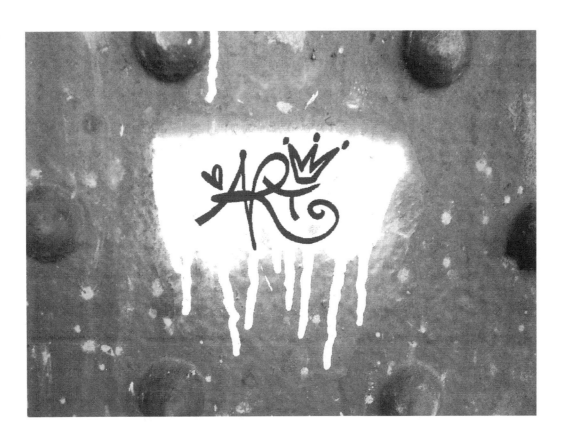

Made in the Unites States of America

LEARN TO DRAW A GRAFFITI MASTER-PIECE

BY GRAFFITI DIPLOMACY

YOUR ESSENTIAL GUIDE TO TAGS, BUBBLE LETTERS, WILDSTYLE, LAYOUT AND PIECING

Learn To Draw A Graffiti Master-Piece: Your Essential Guide To Tags, Bubble Letters, Wildstyle, Layout & Piecing

This book was conceived and designed by Graffiti Diplomacy

Published By Graffiti Diplomacy
Brooklyn, New York

First Printing, 2012
ISBN-13: 978-0-9887772-9-3
ISBN-10: 098877729

Special thanks to all the talented graffiti artists out there whose steps we follow in.

For general information on our other products and services, please contact us at *graffitidiplomacy@yahoo.com*

Find us on the web @ *graffitidiplomacy.com*

Please report any errors by sending a message to *graffitidiplomacy@yahoo.com*

Disclaimer
While we totally support the artform of graffiti, we do not encourage or condone any act or form of vandalism or any illegal activity relating to such whether it be to private, commercial, or public property. Do not write on public or private property without express permission from the owner.

DEDICATED TO
DR. LEONARD DEUTSCH

TABLE OF CONTENTS

SECTION THREE

SECTION FOUR

SECTION FIVE

SECTION SIX

ABOUT THIS BOOK

THIS IS A BOOK ABOUT LETTERS AND LETTERING!

Welcome to the fascinating world of graffiti art. The essential thing you need to know is that graffiti art started with people writing their names. So graffiti art is about letters. More importantly, it's about modifying letters. And not just any letters. Graffiti letters are letters in motion. They are letters with expression and energy. Graffiti letters bend, twist, split apart, lean forward, fall over, fold, flip, blend into each other, or tear apart into fragments. They collapse, morph into objects, inflate like balloons, or explode like volcanoes with hot lava pouring down the sides. The fact is that graffiti letters can do just about anything your imagination can dream up. But it all starts with drawing simple letters. If you can write the letters of the alphabet and sign your name, you can learn to draw graffiti art.

This book is designed to guide you through the process of creating a finished graffiti piece, short for masterpiece. In Section One and Section Two we teach you methods and techniques that you can use to develop your own authentic graffiti letters. In Section Three we cover planning and layout of a whole word or name. In Section Four and Section Five we demonstrate how you can embellish your letters with all of the flashy elements like clouds, flames, 3-D, and drips that make graffiti art so exciting. In Section Six we explain how you can use this book for a group activity or to throw a graffiti art party. To make your graffiti experience a success, we have included two unique patterns that can be turned into stencils to help you construct your pieces. With patience and practice you will eventually develop your own unique style and create your own awesome graffiti art. We have created this book for beginners who want to learn the secrets of this amazing art form. Now everyone can learn to draw a great graffiti masterpiece. Our hope is that this book educates you, empowers you, and inspires you. Let's get started...

GETTING STARTED

SUPPLIES YOU WILL NEED:

- a ream of 8.5"x11" cheap copy paper to draw on. We use the least expensive 20 lb. paper, because it's really thin and you can see through it to trace one drawing on top of another.
- better quality white drawing paper for finished graffiti designs 8.5"x11"
- a pencil
- an eraser
- a ruler
- a pointy black magic marker: you can use a Sharpie, but you must be very careful to place a thick piece of cardboard under your drawing paper so it does not stain your table
- colored pencils, magic markers or crayons
- a wide-tipped black magic marker

ADDITIONAL SUPPLIES YOU WILL NEED:

- scotch tape
- white school glue
- a scissors
- larger copy paper - 8.5"x14" or bigger
- larger drawing paper - 9"x12" or 11"x14"

OTHER ADVANCED SUPPLIES YOU MIGHT LIKE TO TRY THAT YOU CAN FIND IN AN ART SUPPLY OR OFFICE SUPPLY STORE:

- black water-soluable Ink
- an assortment of soft and stiff paintbrushes
- a chisel tip magic marker
- a lightbox
- clear contact paper or laminate

Learning to draw graffiti letters is like learning a sport or a musical instrument - the more you practice the better your letters will get!

DON"T BE AFRAID TO COPY OR TRACE AS YOU PROGRESS THROUGH THIS BOOK - THAT'S HOW WE ALL LEARN. EVENTUALLY YOU WILL DEVELOP YOUR OWN STYLE!

TOOLS

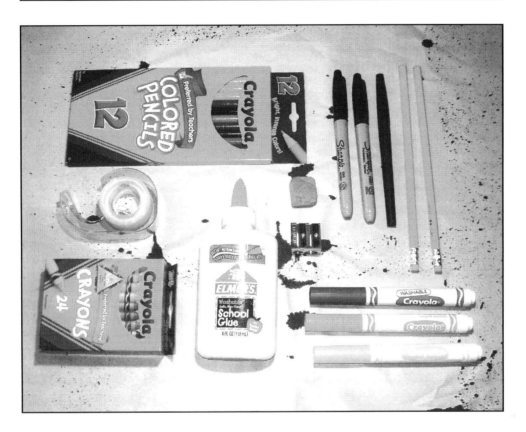

The materials shown above are a sampling of some of the basic materials you should gather together for your graffiti art. All you need to get started right away, though, is a pencil, paper and an eraser. Not pictured are some more specialized tools that you might like to try, such as a light-box to make tracing easier, water-soluable inks, brushes, and lots more magic markers with different sized tips, alcohol based magic markers, watercolor paints, and a white paint marker.

Take a good look through this book first before you start to draw. Then when you feel ready you can either assemble the patterns for stencils at the back of the book before you start or make them later when you need them.

SECTION ONE

BASIC
LETTERS

CHAPTER ONE
THE THREE BASIC LETTER STYLES

There are three styles of alphabets on which graffiti letters are based. They are:

BUBBLE LETTERS - BLOCK LETTERS - TAG LETTERS

Bubble letters are fat and puffy and are drawn with soft, curvy edges. They are light-hearted and fun to draw. You can draw them as *bubbly* as you like and decorate them with any number of patterns and designs.

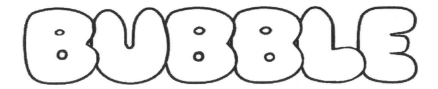

Block letters are drawn with straight lines and evenly spaced curves. They have sharp, pointy edges. The letters on a standard computer keyboard are a good example of block letters.

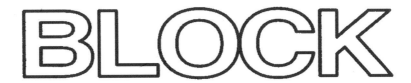

A tag is the same thing as a signature. Tag letters begin with writing your name in your natural handwriting. Tag letters are drawn free-style and are often leaning over to the side to capture a feeling of movement and energy.

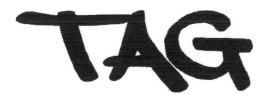

Graffiti art is all about modifying and transforming letters. No matter which style of letter you are working with, the techniques for modifying them are similar. But before you can start to modify letters, you have to learn how to construct the three basic letter forms. It's kind of like constructing a building. You need to create a strong foundation first and then you can build anything you want!

So we'll begin this book by examining the three basic letter forms closely. We're going to devote quite a bit of space to this first section, because it is so important and fundamental to developing your graffiti skills.

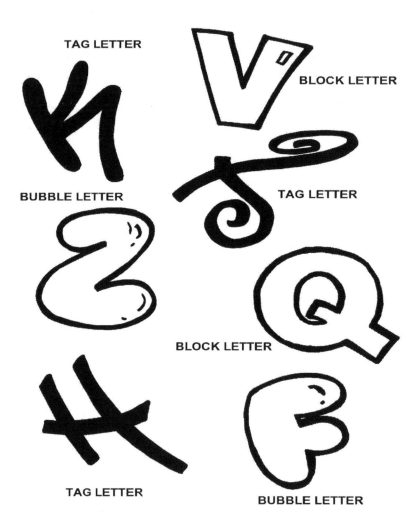

NOTE: Throughout this book we will be using *guidelines* to form letters. Guidelines are lines you place on your drawing with or without a ruler to help you determine where your letter strokes go. Guidelines are an essential tool in graffiti lettering and can be drawn with a pencil, pen or markers.

CHAPTER TWO
SERIF AND SANS-SERIF LETTERS

Each lettering style can be drawn with or without serifs. A serif is a decorative flourish extending from the upper and lower ends of the strokes of a letter. To us serifs look like little feet.

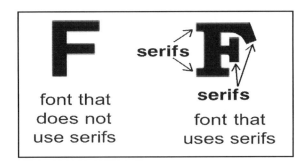

A sans-serif letter is one that does not have small strokes at the ends. The term comes from the French word sans, meaning "without".

SERIF BUBBLE LETTERS

SANS-SERIF BUBBLE LETTERS

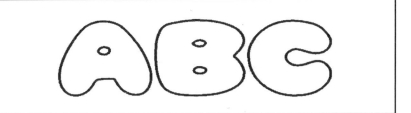

SERIF BLOCK LETTERS

SANS-SERIF BLOCK LETTERS

SERIF TAG LETTERS

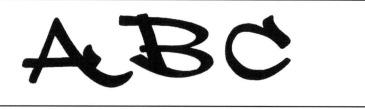

SANS-SERIF TAG LETTERS

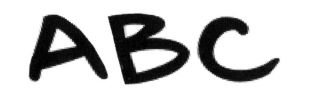

Letters with serifs are especially useful in graffiti art, because the serifs can be stretched, squeezed and manipulated to modify and form unique letters. We will cover letter modification extensively in Section Two.

Bubble letters are soft and round and have smooth edges. They can be drawn in an infinite variety of shapes and sizes. Bubble letters are stylish, fun and versatile. You can use them on all kinds of projects like gift cards, report covers, t-shirt designs, scrap books, or invitations.

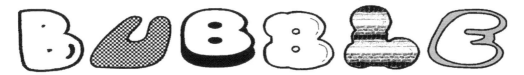

Bubble letters are also known as "softie letters". Drawing them is easy to learn and we will show you one technique you can use to do the whole alphabet from A to Z. Then we will show you how to draw a whole word or a name. Once you learn the basics you can begin to invent your own styles. Many great styles of bubble letters were invented by graffiti artists who use them to make their names big, bold and colorful.

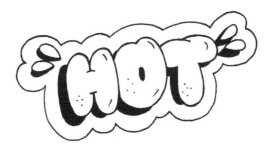

Graffiti artists use bubble letters to create a special kind of design called a throw-up or throwie. In a throw-up, bubble letters squeeze together and overlap into a single shape which is surrounded by an outline. The word "HOT" above is an example of this style of design. To make your own throw-up first draw one letter, than draw the next one slightly behind it, and the next one behind that, and so on. Then draw an outline around the whole shape. Remember to keep your corners soft and rounded. Throw-ups are usually made with two colors: black and white or black and silver.

HOW TO DRAW BUBBLE LETTERS USING GUIDELINES

STEP 1. Draw a capital letter "A" with a pencil.

STEP 2. Draw an outline all around the outside edge of the "A". Make the outline the same distance from the letter all the way around.

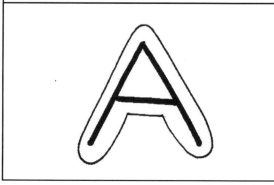

STEP 3. Draw a second outline around the first one to make your letter even fatter.

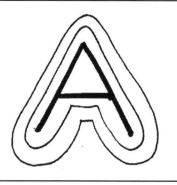

STEP 4. Draw little circles on the ends at the bottoms and top to make your letter look rounder and puffier. This step is optional!

STEP 5. Draw a thick, dark outline all around the outside edge of the letter. Make your letter look soft and bubbly with no sharp corners or edges.

STEP 6. Erase all of the interior guidelines. You can add small curved lines on the inside of your letter to make it look really puffy.

12

STEP 1. Draw a capital letter "B" with a pencil.

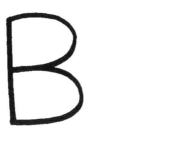

STEP 2. Draw an outline all around the outside edge of the "B". Make the outline the same distance from the letter all the way around.

STEP 3. Draw a second outline around the first one to make your letter even fatter.

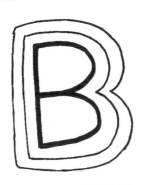

STEP 4. Draw little circles on the sides at the bottom and top to make your letter look rounder and puffier. This step is optional!

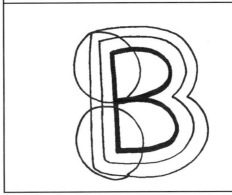

STEP 5. Draw a thick, dark outline all around the outside of the letter. Make your letter look soft and bubbly with no sharp corners or edges.

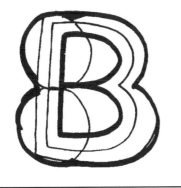

STEP 6. Erase all of the interior guidelines. You can add small curved lines on the inside of your letter to make it look really puffy.

STEP 1. Draw a capital letter "C" with a pencil.

STEP 2. Draw an outline all around the outside of the "C". Make the outline the same distance from the letter all the way around.

STEP 3. Draw a second outline around the first one to make your letter even fatter.

STEP 4. Draw little circles on the ends at the bottom and top to make your letter look rounder and puffier. This step is optional!

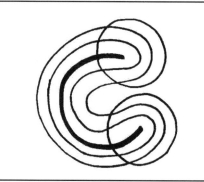

STEP 5. Draw a thick, dark outline all around the outside of the letter. Make your letter look soft and bubbly with no sharp corners or edges.

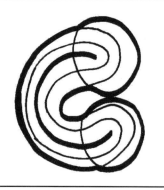

STEP 6. Erase all of the interior guidelines. You can add small curved lines on the inside of your letter to make it look really puffy.

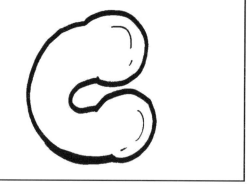

Next, we have drawn letters "D" through "Z" following the same series of steps, just smaller, so you can see where to put the little circles and how to form the letters. Try it yourself and remember to make your bubble letters fat and puffy, and with softly curved edges.

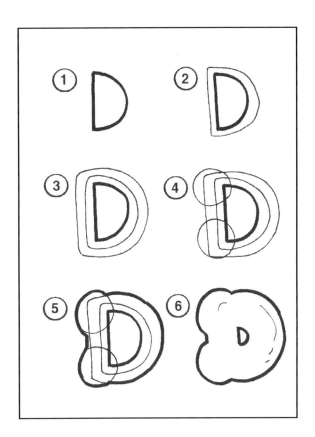

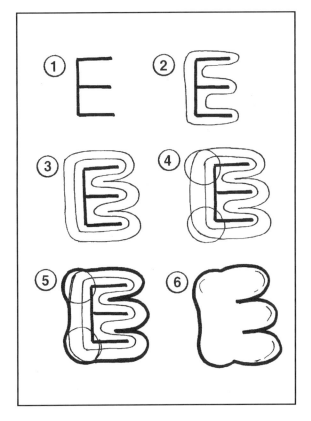

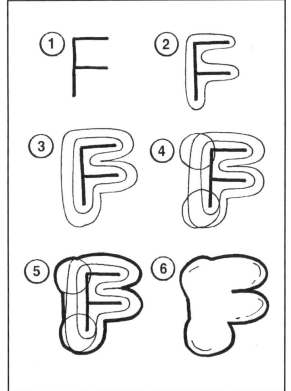

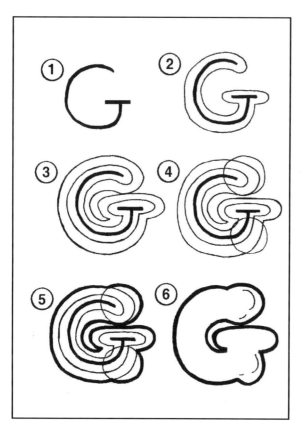

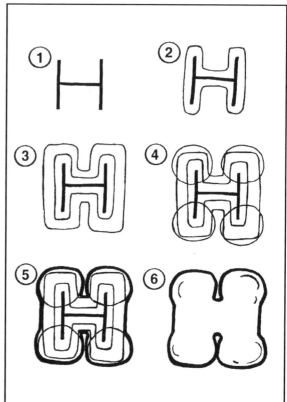

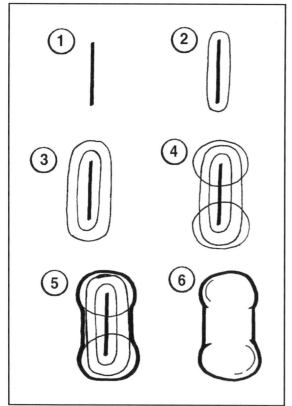

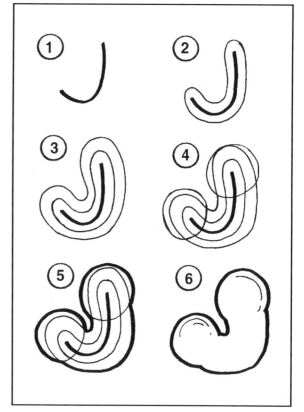

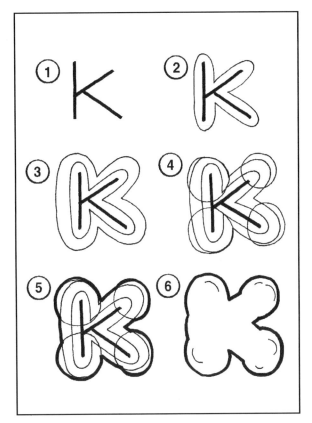

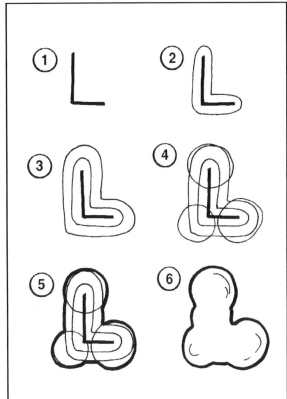

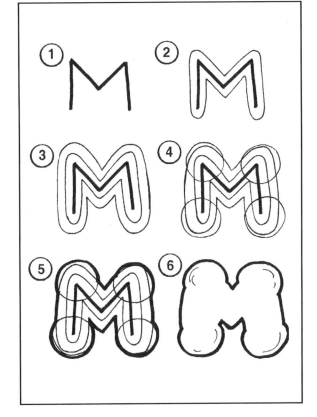

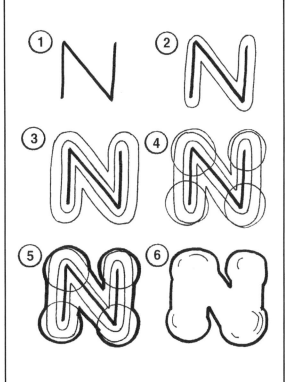

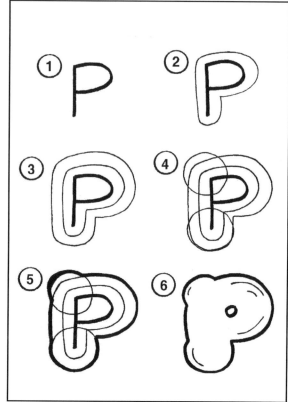

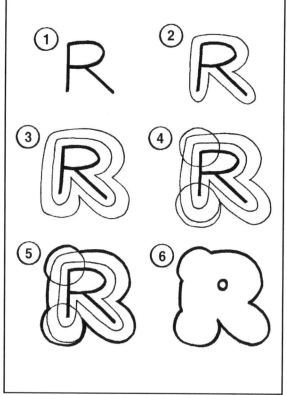

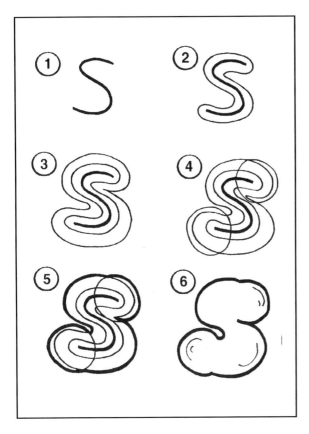

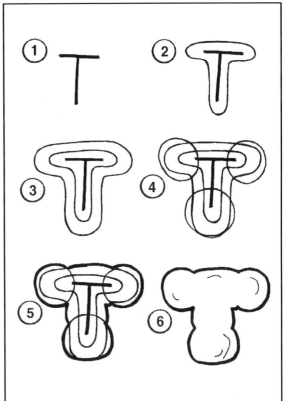

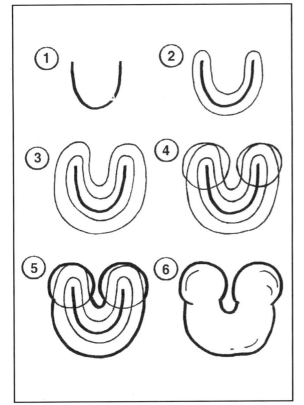

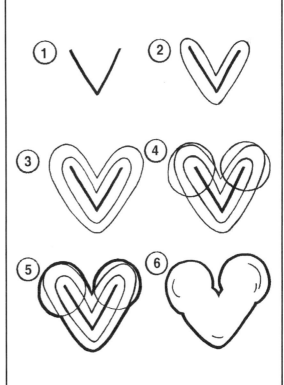

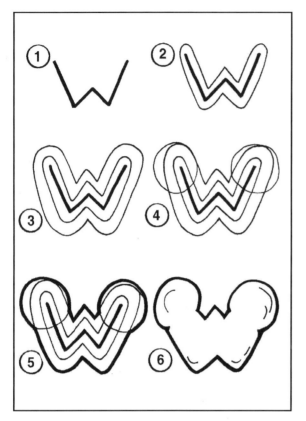

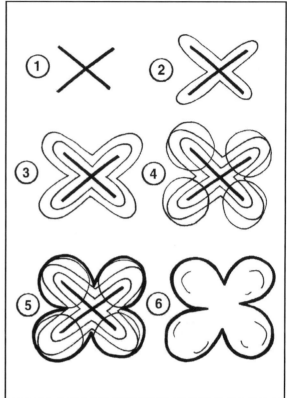

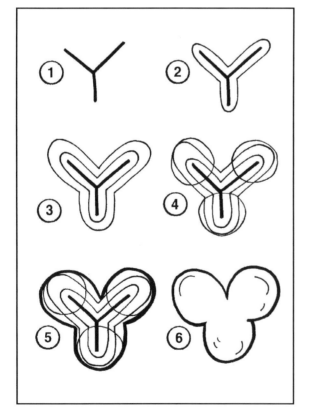

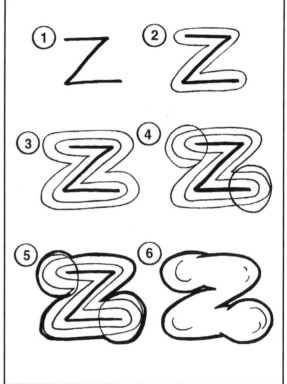

BUBBLE LETTER ALPHABET

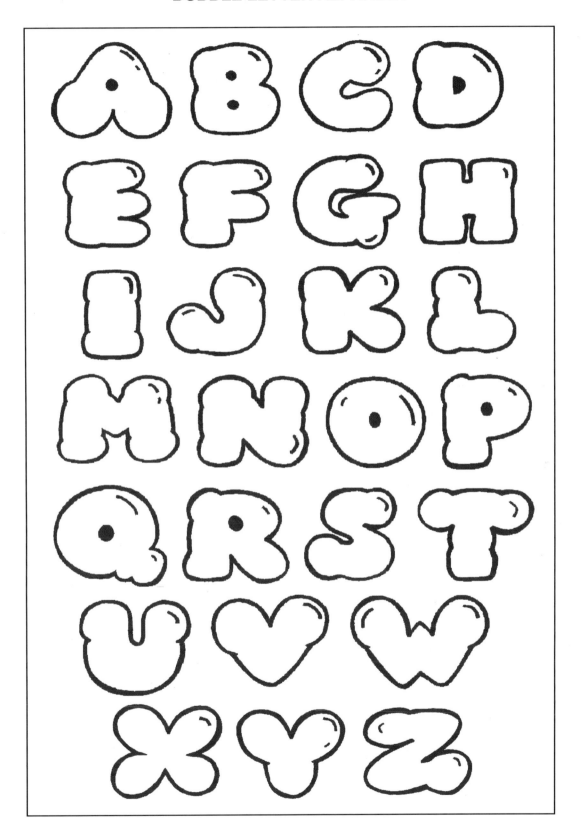

Here is an example of a whole word drawn in bubble letters. Use guidelines just like you did with single letters. In STEP 4, you will redraw your finished letters closer together and overlapping a little bit. The best way to redraw your letters is to trace them onto a clean sheet of paper.

STEP 1. Write out a word with a pencil. Space the letters far apart.

STEP 2. Draw an outline all around the outside edge of each letter. Draw a second outline around the first one to make the letters as fat as you want. Draw small circles on the ends to make the letters really puffy.

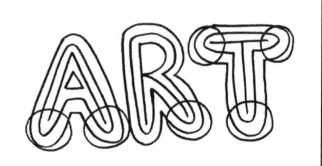

STEP 3. Draw a darker outline all around the outside edge of each letter. Make your letters soft and bubbly. Erase all the inside guidelines. Draw little lines inside of each letter to make it really bubbly.

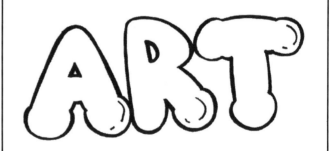

STEP 4. Redraw the letters with the edges overlapping. You can trace them on a clean sheet of paper to make it easier. Then draw an outline or *force-field* surrounding the whole word.

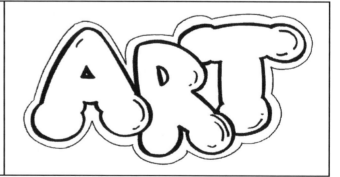

Here is an example of the name "LEROY" drawn in bubble letters. Leroy did not draw the little circles on the ends of the letters, but they work great without them. This technique is very flexible, so learn the rules first, then stretch and change them however you want. When the letters are finished, draw an outline or *force-field* surrounding the whole word.

STEP 1. Write out your name with a pencil. Space the letters far apart.

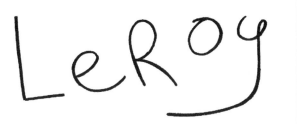

STEP 2. Draw an outline all around the outside edge of each letter. Draw a second outline around the first ones to make the letters as fat as you want.

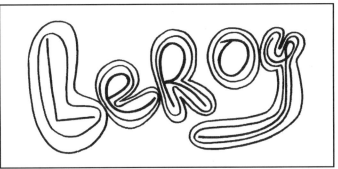

STEP 3. Draw a darker outline all around the outside edge of each letter. Make your letters soft and bubbly with no sharp corners. Erase all of the interior guidelines.

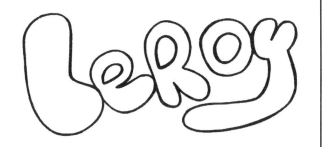

STEP 4. Redraw the letters with the edges overlapping just a little. Draw a force-field surrounding the whole name.

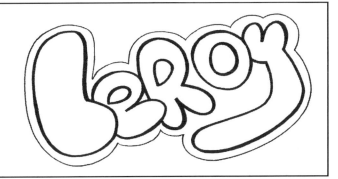

HOW TO DRAW A THROW-UP

After you practice drawing your bubble letters for a while, you will be able to draw them freehand. Then you can add details, like a drop shadow or 3-D and a force-field to make your drawing into a throw-up. (We will cover 3-D letters in detail later on in this book.)

STEP 1. Sketch out your bubble letters in pencil with the letters overlapping. Keep the edges smooth and rounded.

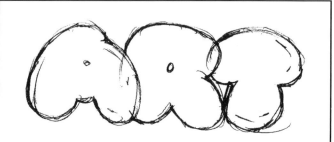

STEP 2. Redraw the letters with a dark, sharp outline. Erase any unneeded guidelines or trace your drawing onto a clean sheet of paper to make it fresh and crisp.

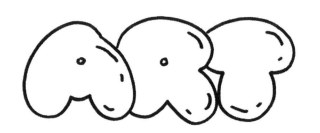

STEP 3. Add a little drop shadow or 3-D along one side of each letter. Make sure the drop shadow or 3-D is on the same side for all three letters.

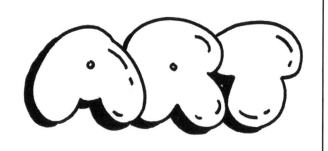

STEP 4. Draw a force-field surrounding the whole word including the drop shadow or 3-D. Practice drawing this throw-up many times until you can draw it very quickly.

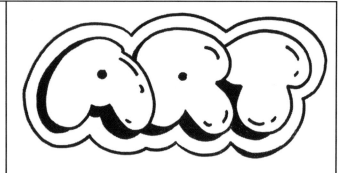

Block letters are a plain style of lettering in which the letters are written upright, have squared-off, sharp corners on the edges, and usually have strokes that are almost the same thickness. Strokes are the lines and curves that form the shape of a letter. Block letters tend to have lots of straight lines and evenly spaced curves on letters like "S" and "O". Because they are simple to draw and easy to read, they are frequently used on signs and posters. Both block letters and bubble letters work really great as graffiti outline letters. Outline letters are letters that have an outline and empty spaces in the middle that can be filled in with patterns and decorations.

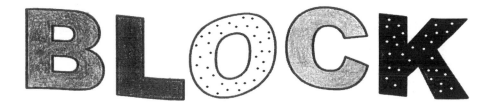

Block letters are an essential element in graffiti art, because they are the building blocks of more complex letter styles. So you will need to practice and learn to draw them well. Two examples of block letter alphabets that you can find on your computer are Helvetica and Aerial. Just look at your keyboard to see a good example of block letters. Block letters can be drawn with or without serifs, but we will begin our block letter exercises with sans-serif letters. The best way to draw block letters that are balanced and well proportioned is to form them with the help of guidelines. We used rounded guidelines in the last chapter to form bubble letters. Now we will use straight and curved guidelines to form block letters. Turn to the next page to get started with the letter "A" and then copy the whole alphabet for practice

BASIC INSTRUCTIONS FOR DRAWING BLOCK LETTERS

Follow these step-by-step instructions. Draw the strokes and then the guidelines. We have colored the section we are focusing on in each step with light grey to make it really clear, but you don't need to do that. Just draw the strokes and guidelines.

STEP 1. Draw an "A" with a pencil. It should be 2 vertical strokes and 1 horizontal stroke.

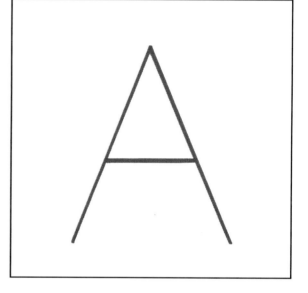

STEP 2. Draw 2 guidelines along the left stroke of the "A". Make the guidelines the same distance apart from the stroke.

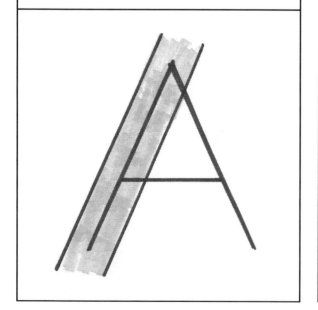

STEP 3. Now draw 2 guidelines on the other stroke of the "A" equal distance apart.

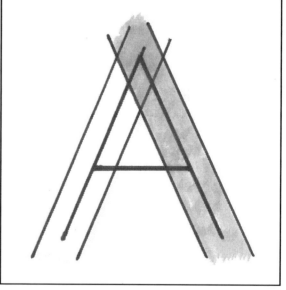

STEP 4. Draw 2 guidelines on either side of the middle stroke of the "A". Again make them equal distance apart.

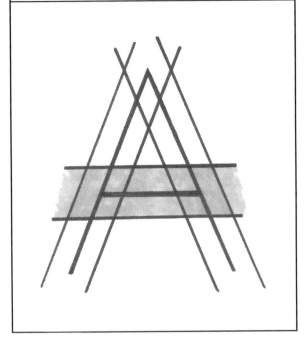

STEP 5. Draw a dark line at the top of the letter. Then draw lines at the bottoms to finish off the ends of the strokes.

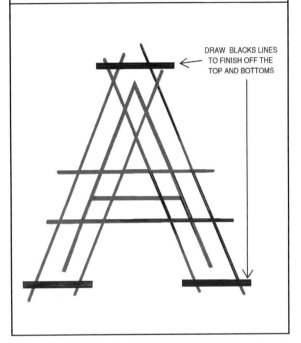

DRAW BLACKS LINES TO FINISH OFF THE TOP AND BOTTOMS

STEP 6. Draw a darker outline all around the outside edge of the letter and erase all the inside guidelines. You can also trace the finished letter onto a clean sheet of paper. Whether you erase the guidelines on the original sketch or just trace it onto a new sheet of paper, you'll have an excellent looking block letter "A" that you can use as a base on which to build other styles of letters.

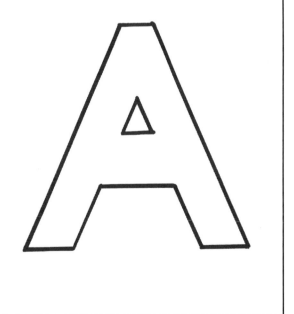

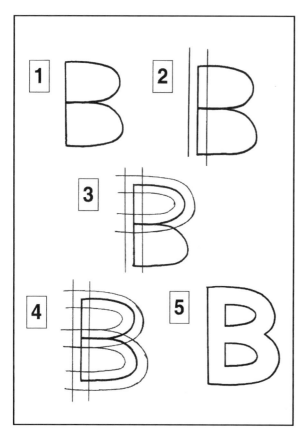

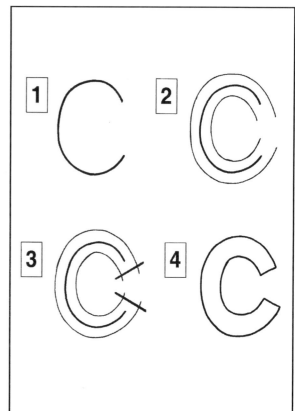

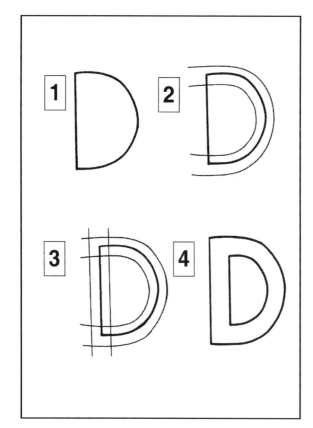

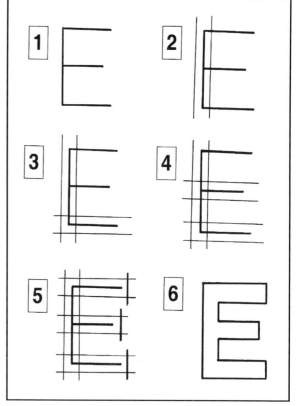

28

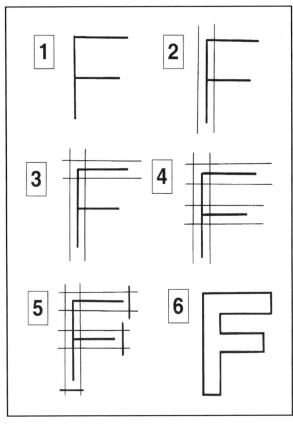

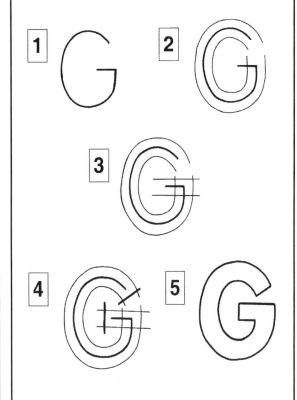

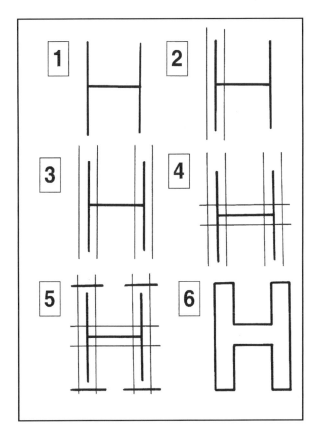

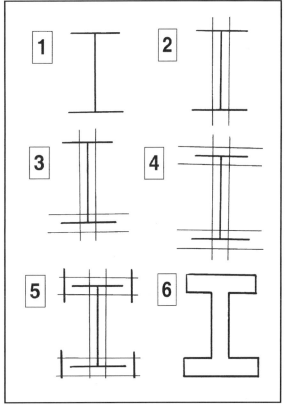

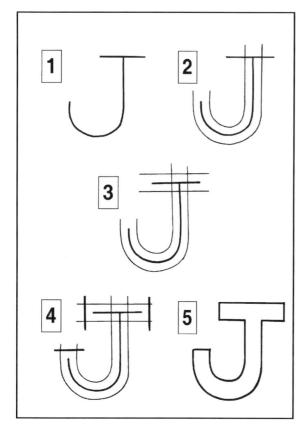

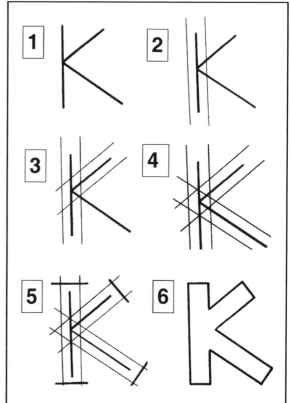

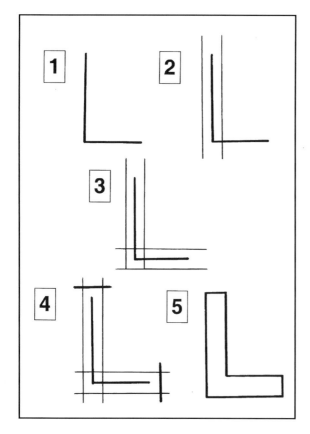

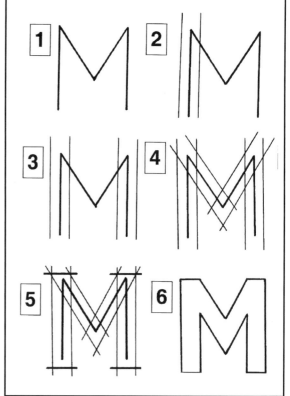

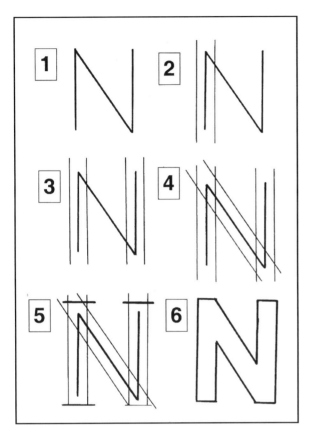

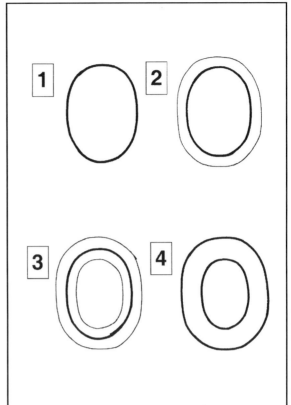

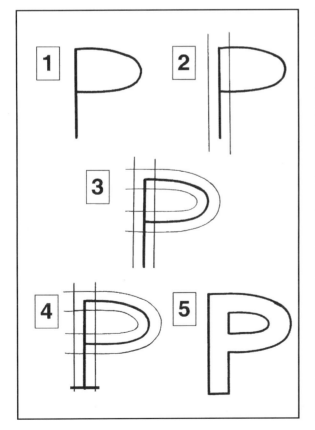

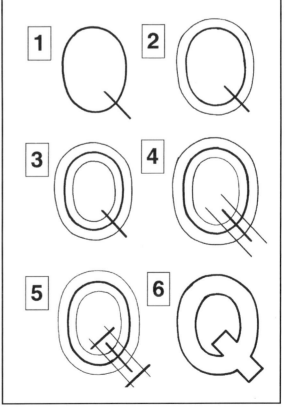

31

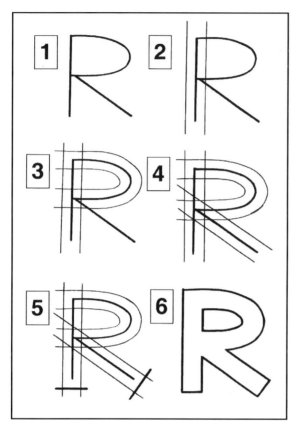

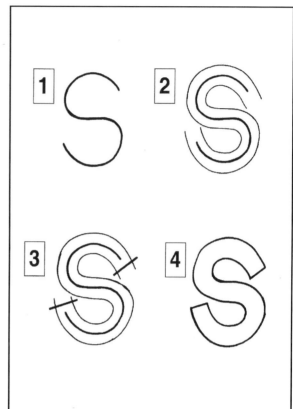

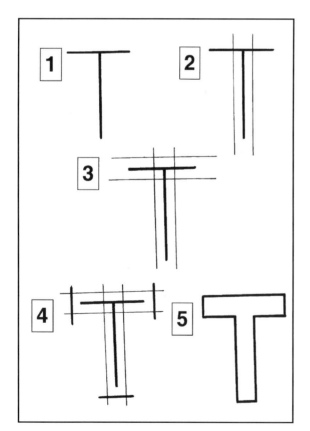

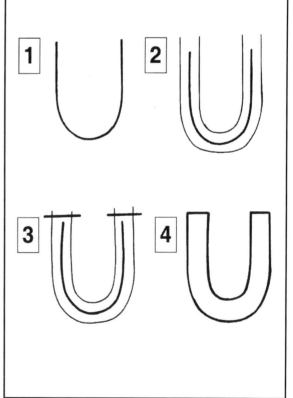

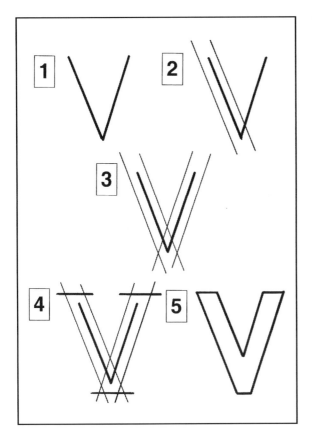

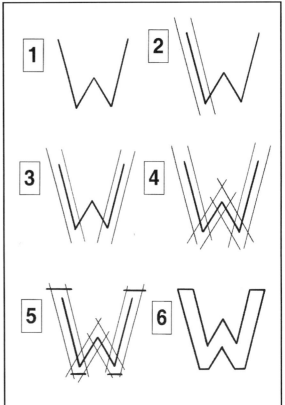

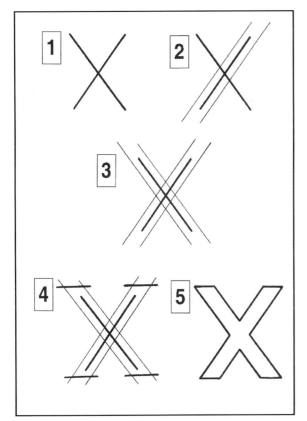

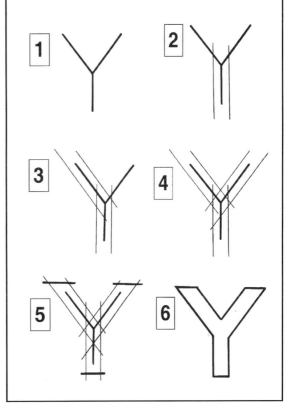

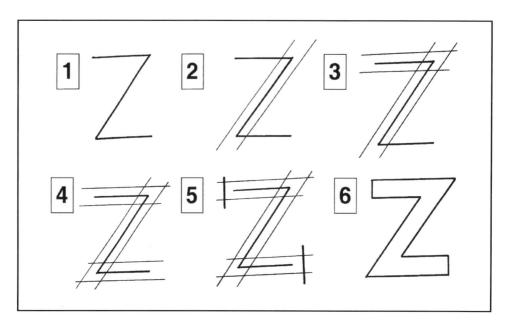

If you want to create block letters that are evenly sized you can use a combination of guidelines and a grid to create almost perfect letters. A grid is a pattern of regularly spaced squares on a chart. Here is an example of the block letter "A" drawn on a grid. The steps are exactly the same as the previous pages using guidelines. If you want to form your letters on a grid, just make sure the height of all the letters fill up approximately the same amount of squares to make them all the same size. The width will be different, because some letters are narrow, such as "I", and some letters are wide, such as "W".

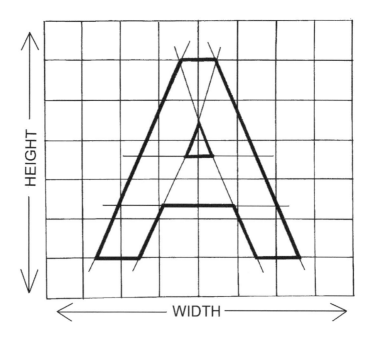

BLOCK LETTER ALPHABET

A B C D E
F G H I J
K L M N O
P Q R S T
U V W X
Y Z

Here is an example of a name drawn in block letters. Use guidelines just like you did with single letters. When the letters are finished, draw a force-field surrounding the name. Another name for a force-field is a *glow*.

STEP 1. First draw your name lightly with a pencil. Spread the letters out so you have room to build them up.

STEP 2. Form each letter into a block letter using guidelines.

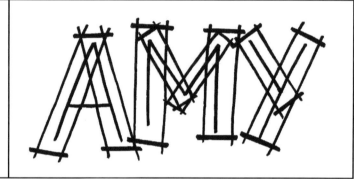

STEP 3. Draw a dark outline all around the outside edge of each letter and erase all the inside guidelines.

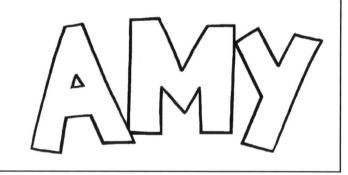

STEP 4. Redraw or trace the letters closer together and overlap some edges just a little bit. Draw a force-field or glow surrounding the whole name or word. Add small dots on the edges.

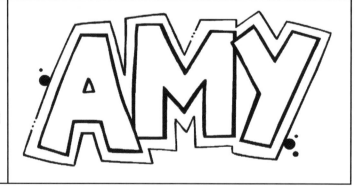

HOW TO DRAW A SERIF

A serif is a decorative flourish extending from the ends of the strokes of a letter. Serifs make letters look more elegant. They come in many different styles and are often used in books or newspapers for blocks of text, because they are easier to read than sans-serif letters. A serif runs into and flows from the main stroke of a letter in one continuous, sweeping line and is not a separate part. Serifs are not intended to be perfectly geometrical or straight and should be drawn free hand. In graffiti art serifs can be exaggerated and elongated, serving as ornaments and links between letters. We'll get to that later on. Follow the steps below to add serifs to a letter "I".

NOTE: This sentence is typed with a serif font called *Georgia*.

STEP 1. Draw a block letter "I".

STEP 2. Draw a small bar on top and a small bar on the bottom to form serifs.

STEP 3. Connect the small bars and the stem with continuous, flowing lines.

STEP 4. The serifs should curve very slightly inward towards the stems. Erase all of the guidelines and you have your finished serif letter.

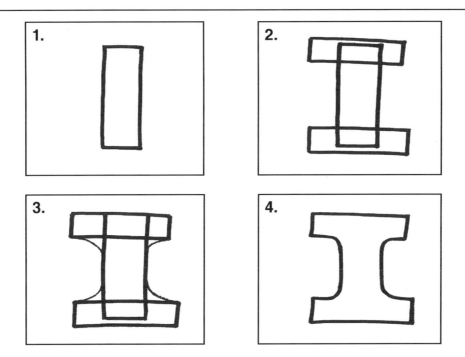

You can add serifs to any letter in any style. Try these for practice.

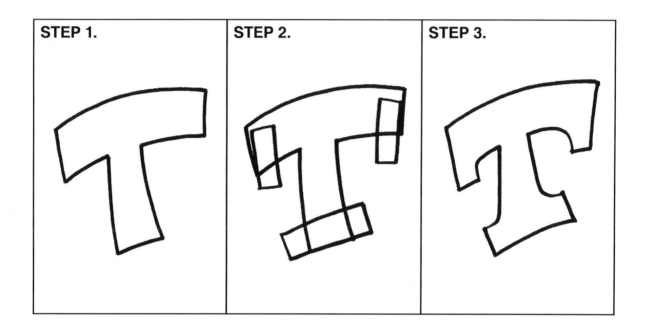

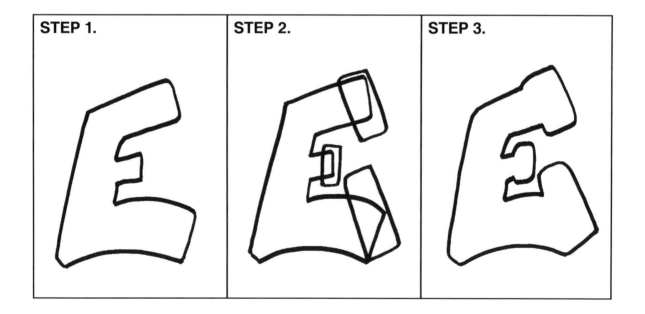

HOW TO DRAW TAG LETTERS

One of the things we all know how to do is sign our name. Let's see how we can turn a simple signature into a graffiti tag. Tag writing is similar to calligraphy. Calligraphy comes from the Greek words KALLI (beautiful) and GRAPHIA (writing). It is defined as the art of writing. In fact graffiti artists refer to themselves as writers.

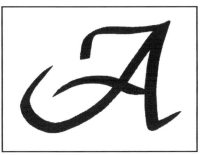

In the box on the left is an example of a calligraphic letter "A". In the box below are three tag letter "A's". You can see the similarity between them. Both the calligraphic letter "A" and the tag letter "A's" are created with sweeping, rhythmic movements and lots of extended lines.

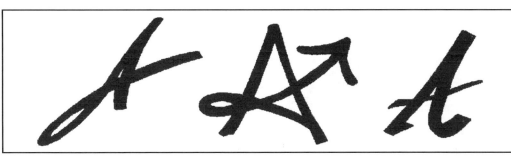

But what exactly is a tag?

A tag is simply a signature, like an autograph. The word "ART" on the front of this book is a tag. And how do you pick a tag name? Easy! It is some form of nickname that you pick for yourself. It can be anything: a word that you like, your initials, a mixture of your favorite letters and numbers, a secret code, or even a symbol, like a stick figure or an animal paw. Tags are usually short with two to five letters. Sometimes tag names are chosen simply because the letters work really well together. You can find many great examples of tag letters on the internet. There are hundreds of different styles. In fact there are as many styles as there are people because everybody's handwriting is unique.

Here is an assorted collection of tag letter "A's". Copy these letters a few times on a piece of paper to get a feel for how they flow. Trace them if you like. Draw them in the air a few times. Drawing letters in the air can help you learn faster. Really exaggerate the movements. You can find many more examples of tag letters on the internet to practice with. IMPORTANT: Only draw your tag letters on paper, like any other art form! That's what we do.

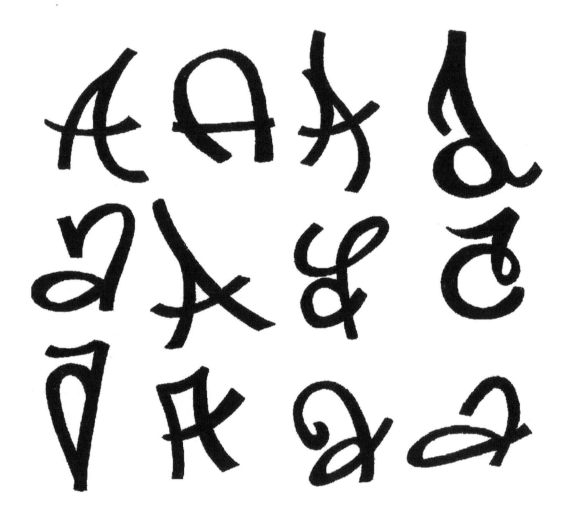

Notice that all of these examples tend to lean over to one side like italics. Italics are letters that slant to the right. Tag letters are a little different, because they slant to the left. It doesn't matter how you draw a tag letter, just make sure you add lots of movement and make it expressive when you draw it.
Think *action* and *motion*.

Since tag letters are a freestyle form of letters, we cannot give you an exact set of instructions on how to draw them like we did with bubble letters and block letters. Here is a very basic tag alphabet that you can copy or trace to get started. Notice that the letters have a lot of movement, as opposed to block letters which are very stiff and straight up-and-down.

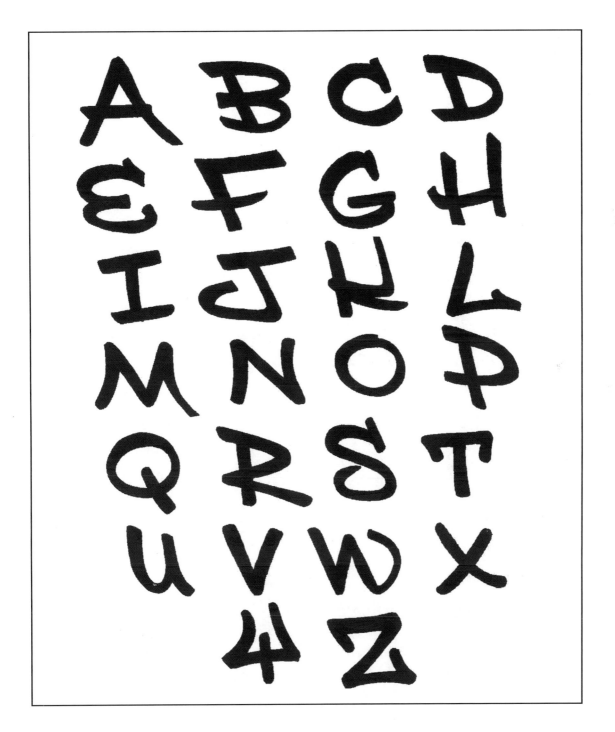

Now we're getting somewhere. This tag alphabet is more stylized and has lots of exaggerated lines. When drawing tag letters try using your whole hand or arm and keep your wrist loose and free. Trace these letters at first or simply copy them. Change the letters any way that you like. It takes time, patience and practice to learn any art form and this one is no exception. When you feel that you can write the letters with your eyes closed, you have gotten it. Drawing tag letters is a lot of fun and actually feels good once you know how. Make your letters dance as you draw them. Choose one letter and practice drawing it a lot.

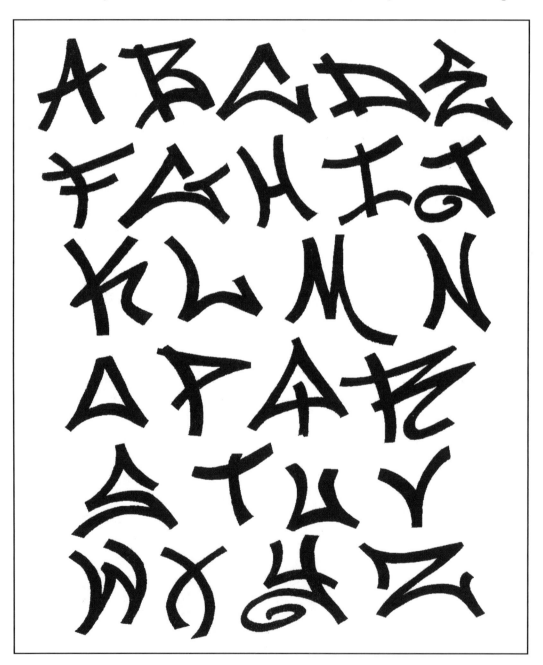

There are several common elements that can be found in many tags. Along with slanted letters, writers add details like crowns, halos, arrows, stars, hearts, brackets, exclamation points, underlines, clouds or fancy curlicues and swirls to their names. You can add as many of these details as you like to your own tag.

DIFFERENT DESIGN ELEMENTS YOU CAN ADD TO YOU TAG!

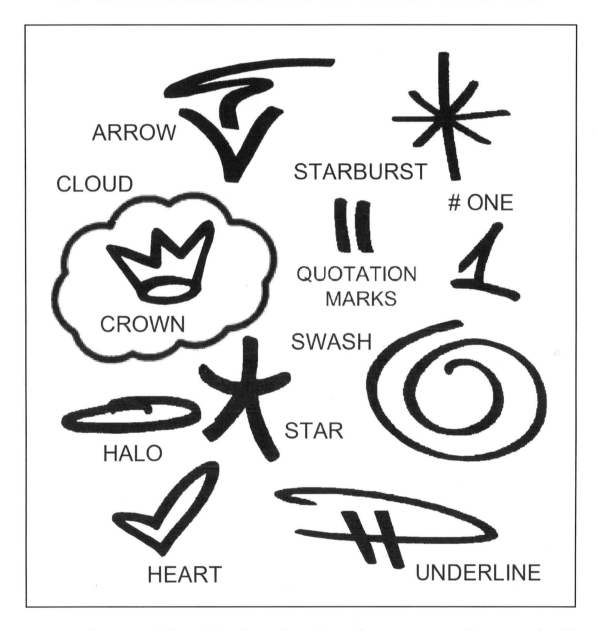

ARROW

STARBURST

CLOUD

ONE

CROWN

QUOTATION MARKS

SWASH

HALO

STAR

HEART

UNDERLINE

Tags are drawn quickly which gives them lots of movement and energy. Graffiti art started with people writing their names in tag form and evolved from there into a whole complex system and art form. Amazing!

YOUR TAG IS YOUR IDENTITY, BRAND, & LOGO

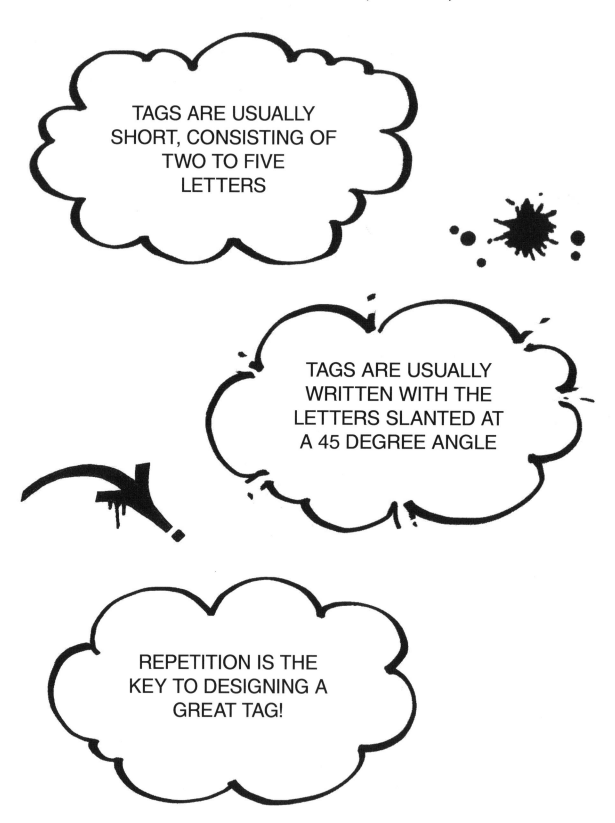

TAGS ARE USUALLY SHORT, CONSISTING OF TWO TO FIVE LETTERS

TAGS ARE USUALLY WRITTEN WITH THE LETTERS SLANTED AT A 45 DEGREE ANGLE

REPETITION IS THE KEY TO DESIGNING A GREAT TAG!

HOW TO DESIGN YOUR OWN TAG

The first step is to choose a tag name for yourself. Or a word that you like.

To create your own tag you will start out by drawing or writing your chosen tag name or word in a variety of different tag style letters. The secret to designing a great tag is to draw it over and over again until it becomes a distinct, interesting design. You won't know where it's going till it gets there. Get a pencil, crayon or a magic marker and a piece of paper. Start writing your chosen tag name or word.

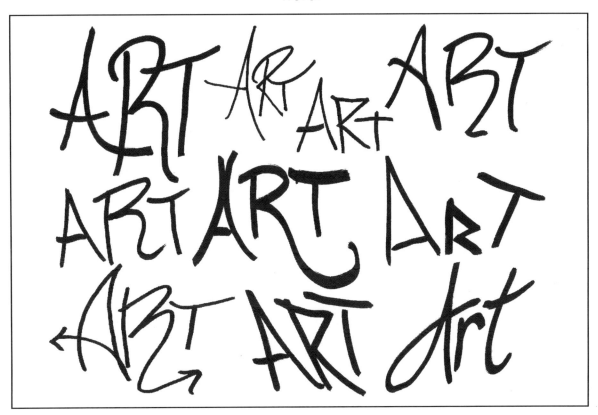

Write it in script or print letters or a mixture of both. Write it with slanted, tag style letters. Write it with capital or small letters. You can look on the internet for examples of tags to give you ideas. Just search the terms "tag letters" or "graffiti tags". Write it at least twenty or thirty times. That sounds like a lot, but remember this is a piece of artwork and it takes time to develop. You will begin to notice that it starts to feel automatic, kind of like you can write it in your sleep. Write it with your eyes closed. It has a rhythmic, repetitive motion that feels good. If you do it enough times it begins to develop a kind of pattern. In the example above, we have drawn our tag word "ART" in a variety of interesting letter styles and configurations.

Continue writing your name. Don't worry about how your drawing looks yet – you are just warming up. Try writing it different ways. Remember that graffiti art started with people just writing their names. Tag letters are a free-style form of letters, so let your arm and wrist be loose. Make big curvy loops if you like. Experiment and be creative. You can mix up capitol and small letters. Test out interesting design elements, such as one letter flowing into or attached to another letter. Try two letters back-to-back, or one letter higher or lower than the rest. Make one letter bigger or smaller. Or make the first and last letters much bigger. Turn one letter sideways or upside-down. There are no set rules and definitely no shortcuts to this process. Write it with a feeling of rhythm and movement. Eventually that will happen if you write it enough times. You can put your sketches in a cardboard box and number them as you go if you like. This will give you a record of your progress. When you feel you have done enough, go through your sketches and choose one that you like. The one you choose will be your **starting point**. We have circled our starting point in the example below. Your starting point drawing will be the foundation on which you will build your finished tag. On the next page you can see our starting point compared to our finished tag. It's a pretty amazing process, as you will see.

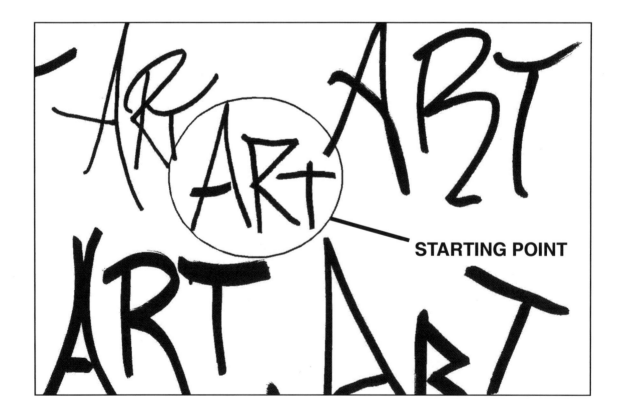

STARTING POINT

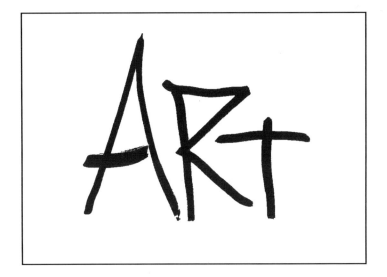

This is our starting point drawing.

And here is our finished tag. Wow, what a difference!

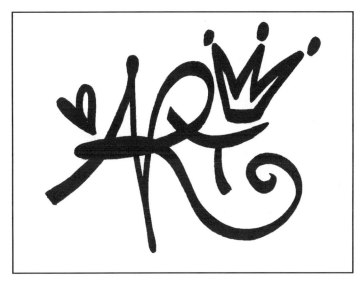

On the following pages we will demonstrate the process of going from a starting point drawing to a finished tag. Look at the finished tag and all of the examples in STEPS 1 – 18 carefully. Then take your starting point drawing and develop it in a similar way. Experiment and try lots of different variations. Add some design elements, like exclamation points, a heart or a star. We'll show you how. Try out as many elements as you like. Look for interesting relationships between the letters. Trace or copy each new drawing as you go. Remember, this is a time consuming, creative process, so take your time. You may want to split your time up and work on your design in several sessions.

To start this exercise you will draw your starting point on a piece of copy paper really big. Then you can begin to alter the letters. Either copy or trace as you go.

STEP 1. Draw the word "ART" on a sheet of paper in basic tag style letters. Draw it big. This is your starting point.

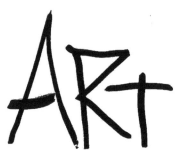

STEP 2. Draw it again, and make the "T" a bit smaller. Then round off the "R".

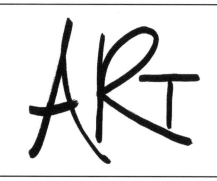

STEP 3. Let the top section of the "T" overlap the top portion of the "R".

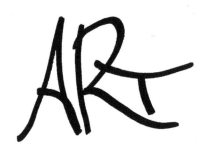

STEP 4. Use the middle section of the "R" to form the cross bar of the "A" so the letters overlap each other.

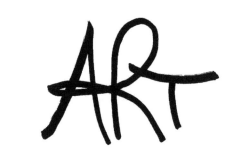

STEP 5. Try moving the "T" away from the "R".

STEP 6. Make big, curvy loops in the "A" and the "R". Add a crown over the "T".

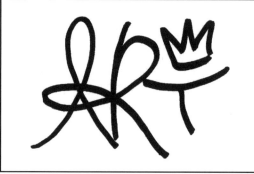

STEP 7. Draw a smaller loop at the top of the "A" and let the "R" overlap the "A" at the bottom. Use a fatter marker.

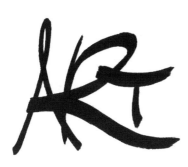

STEP 8. Draw a cloud around the word. We are just experimenting with different ideas at this point.

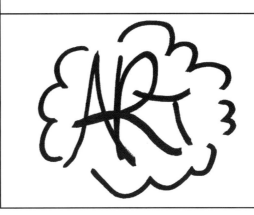

STEP 9. Draw a long, curvy arrow underneath the word. Don't like it? Take it out and try something else.

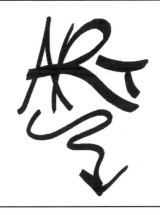

STEP 10. Try drawing a star over the "T". All three letters are overlapping in this variation.

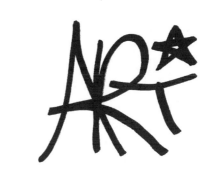

STEP 11. Draw the "A" and the "R" with one continuous line. Now it's starting to get interesting.

ONE CONTINUOUS LINE

STEP 12. Draw a tiny, little "T". Extend and curl the bottom line of the "R" around the "T".

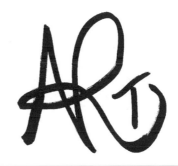

STEP 13. Add a heart and draw the "T" overlapping the "R" like before and remove the curve on the bottom of the "R".

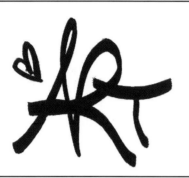

STEP 14. Add a crown over the "T" and stretch the bottom of the "R" a little bit.

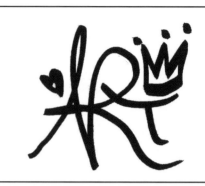

STEP 15. Extend the leg of the "R" more and put an arrow on the end.

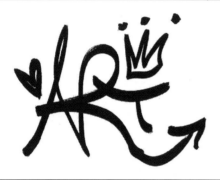

STEP 16. Curl the arrow and try quotation marks on either side of the word. Replace the crown with a star over the "T".

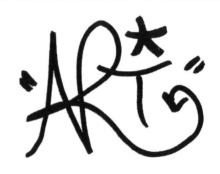

STEP 17. Draw the letters again without the exclamation marks or the star. Make the tip of the "R" into a round curlicue.

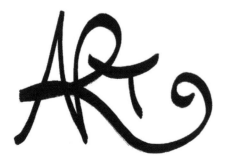

STEP 18. Draw back in the heart and crown and you have a finished tag! That took a lot of experimenting, but eventually it turned into a really nice design. There were many more variations we tried, but these were the main ones.

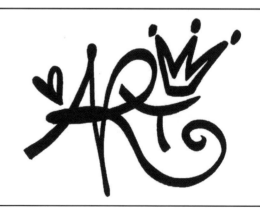

So this completes our lesson on how to design a tag. There were actually about thirty more versions, but these 18 were the most interesting ones. Once you have finished your own tag design, you can go back into your earlier sketches and create a totally different design. The variations are limitless. You won't know what your finished tag will look like until it's done – that's the fun part. We are always surprised by how our own finished tag designs end up. We liked the one we did in this exercise so much we put it on the front of this book and everywhere else we could think of. Remember- it's only by drawing your tag over and over that it will get really good and you will make interesting discoveries about how the letters can work together. Your finished tag becomes a distinct symbol or logo that you can put on all kinds of things, like t-shirts, notebooks and stickers. Think of your tag as an ornament that you can use to decorate your stuff, kind of like a brand name. And the best part – you can have as many tag names as you like.

Draw your tag on a blank t-shirt with a permanent marker. Or scan it into your computer, shrink it, print it, cut it out, and make stickers with double stick tape.

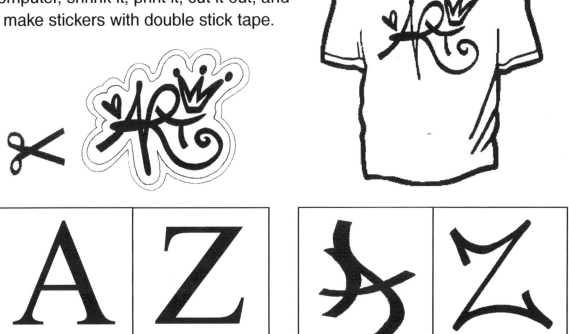

Just to drive home the point, here are the letters "A" and "Z", drawn first in plain Roman letters with serifs, then in tag style letters. Graffiti art began with people writing their names and evolved naturally from tags into more complex styles. The key to learning to draw graffiti is to study and understand tags!

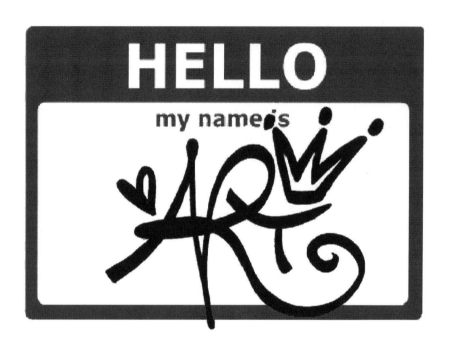

CHAPTER SEVEN
TURN TAG LETTERS INTO OUTLINE LETTERS

The good news about this chapter is that you already have the basic skills you need to turn your tag letters into outline letters. Remember that graffiti artists use many different styles of outline letters to design their pieces. You will be using guidelines for this technique in a similar way you used them to form block letters and bubble letters. First study the examples on the following pages. We start out by drawing capital letters "T" and "K", and then a simplified version of the word "ART". We end with turning our "ART" tag from the last chapter into an outline tag. Copy our examples then use your own tag letters or name for practice. Or use tag letters from the last chapter to experiment with. Think of your tag letters as a skeleton and the outlines as muscles and flesh. As you draw, imagine what you want your finished outline tag letters to look like. Make the outlines chunky and add any changes to the letters you think will look good. Because tag letters are drawn freestyle, they have lots of action and motion. Take your time and make lots of sketches. Keep it simple at first until you get the hang of it.

TAG
LETTERS

OUTLINE
TAG
LETTERS

To turn a tag letter into an outline letter, use guidelines the same way you did when forming block letters. The guidelines serve as a reference - they won't be part of the finished letter, so draw them lightly. We drew them in darkly, just so you can see them clearly. Have your eraser handy.

STEP 1. Start by drawing a tag letter "T" with a pencil.

STEP 2. Draw two guidelines on either side of the middle stroke. Make the guidelines the same distance away from the middle line.

STEP 3. Draw two guidelines on either side of the top stroke. Make them the same distance apart.

STEP 4. Draw dark lines to close off the ends on the top, sides and bottom of the letter.

STEP 5. Draw a dark line all around the outside edge of the "T" and erase all of the interior guidelines.

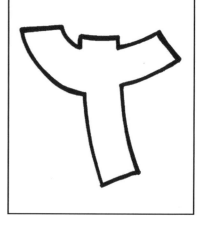

STEP 1. Start by drawing a tag letter "K" lightly with a pencil.

STEP 2. Draw two guidelines on either side of the vertical side stroke. Make the guidelines the same distance apart from the middle line. Follow the curve.

STEP 3. Draw two guidelines on either side of the upper stroke, following the curve. Make them the same distance apart.

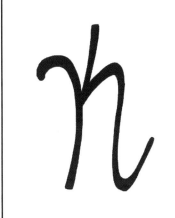

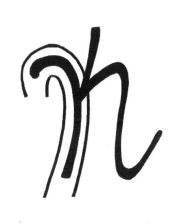

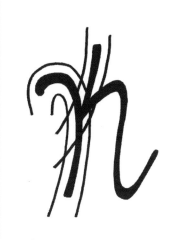

STEP 4. Draw two guidelines on either side of the lower stroke following the curve. Make them the same distance apart.

STEP 5. Draw dark lines to close off the ends on the top, sides and bottoms of the letter.

STEP 6. Draw a dark line all around the outside edge of the "K" and erase all of the interior guidelines.

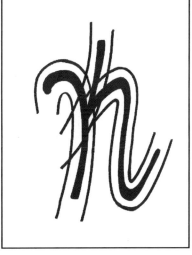

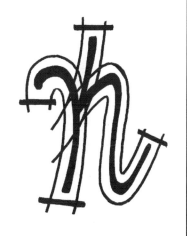

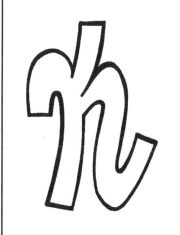

And here is an example of a whole word first drawn in tag letters, than turned into outline tag letters.

STEP 1. Draw the word "ART" in tag letters.	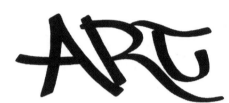
STEP 2. Now move the letters far apart so there is room between them.	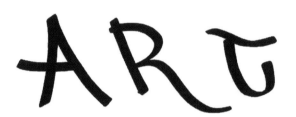
STEP 3. Draw guidelines around each letter and draw dark lines to finish off the ends of each letter. Work on each letter separately.	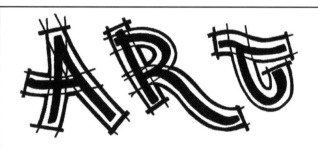
STEP 4. Next erase all of the inside guidelines. Or trace the outlines of the finished letters onto a clean sheet of paper. You now have 3 finished outline letters.	
STEP 5. Redraw or trace the letters, grouping them close together like the original tag you started with. Overlap the edges a little bit. Draw a force-field. DONE!	

Now let's turn to our finished tag from the last chapter. This example is a little more complex, but the steps are basically the same.

STEP 1.

Draw your tag. Separate the letters a little bit, so you have room to build them up. Move the heart and crown just a little bit away from the letters.

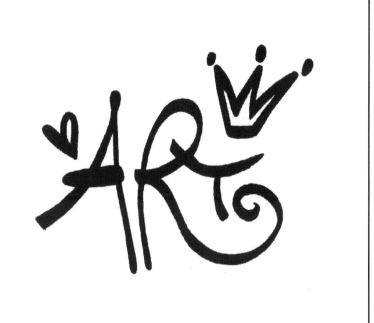

STEP 2.

The next step is to draw guidelines around each letter and the heart and crown to fatten them up. Follow the structure and shape of each stroke. Make the guidelines approximately equal distance from the center lines.

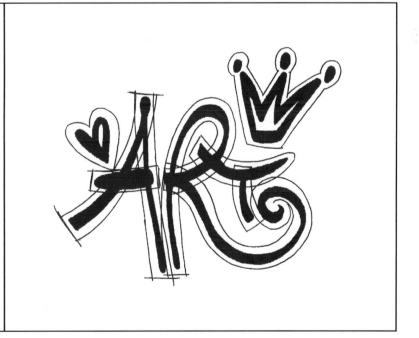

STEP 3.

Try to get the letters as chunky as possible without changing their original shape too much. Make small changes where needed. Sketch out all of the shapes loosely at first. Then you can trace the new drawing onto a clean sheet of paper or just erase the inside lines.

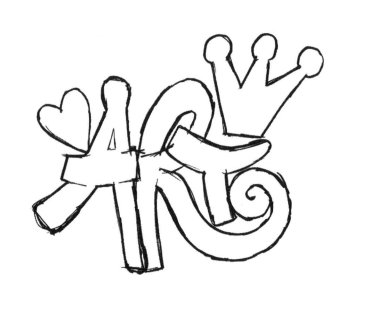

STEP 4.

Round off all of the edges. Redraw the letters, heart and crown with clean, sharp outlines. At this stage you can squeeze the elements a little closer together. Make your new outline tag drawing look as close to the original tag as possible. Add a force-field surrounding the whole shape.

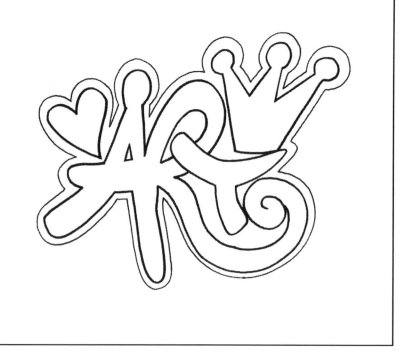

HOW TO BUILD LETTERS WITH BARS

Building letters with bars is the most important technique you will need to know to design graffiti letters. This is one of the secrets to successful graffiti art. You will be using bars in the next section of this book to modify letters. Building letters with bars is very similar to building them with guidelines. In fact the bars are guidelines. Bars are long, squared off shapes that fit around the strokes of a letter. Building letters with bars combines all of the different skills you have learned so far. Bars can be used to build any style of letters, no matter what style of letter you are starting out with. On the following pages, we demonstrate this technique with different letter styles, so you can see exactly how it works. Once again the goal is to turn your letters into outline letters which can be filled in with some kind of design or decoration later on.

STEP 1. Draw an "H" lightly with a pencil so you can erase it later.

STEP 2. Draw a rectangular bar around each stroke of the letter. The edges of the bars should overlap. This letter "H" has 3 bars.

STEP 3. Draw a dark line all around the outside edge of the letter.

STEP 4. Erase all the inside guidelines.

1.

2.
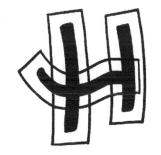

3.
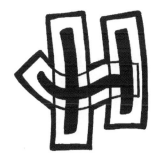

4.
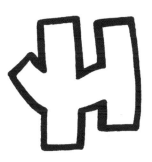

Next, here is an example of a tag letter "S" built in three steps. You can start with any kind of letter. The amount of steps you use to build the letter with bars is up to you and you can apply the steps in any sequence that you want. As long as you end up with an outline letter when you are finished, it doesn't really matter how you get there.

STEP 1. Draw an "S" lightly with a pencil.

STEP 2. Draw bars around each stroke of the letter. The edges of the bars should overlap. This letter has 5 bars.

STEP 3. Draw a dark line all around the outside edges of the letter and erase all the inside guidelines. Blend and smooth the edges of the bars together at the corners. This is your finished outline tag letter "S".

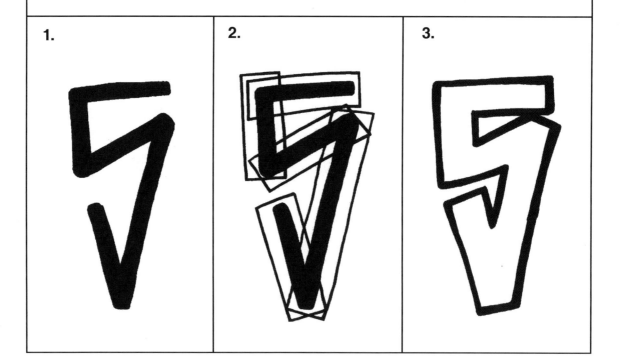

1. 2. 3.

Bars can also be formed with curved lines to follow the shape of a letter that has a curve. In letters that have curved strokes, like an "S", "C" or "P", bend the bars around to follow the curve.

STEP 1. Draw a "P" lightly with a pencil.

STEP 2. Draw a bar around the long, vertical stroke of the letter. Then draw a bar around the curved stroke, overlapping the edges of the bars.

STEP 3. Draw a dark line all around the outside edge of the letter, then erase all the inside guidelines. This is your finished outline letter "P".

1. **2.** **3.**

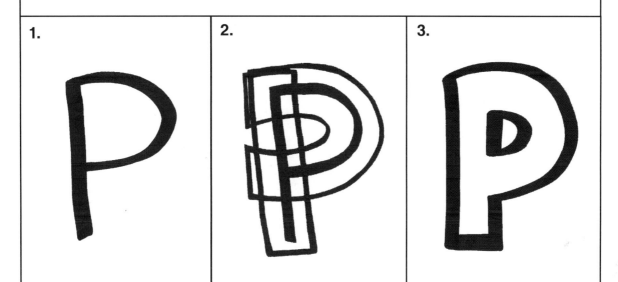

No matter how you bend the letter, it works the same way. Just bend and draw the bars around each stroke.

Here are some interesting, stylized variations of the letter "P". Build these letters with bars in the same way. The edges of the bars don't necessarily have to overlap in the finished letter. Just as long as you end up with an outline version of the letter you started with, you can construct and manipulate the bars any way that you want.

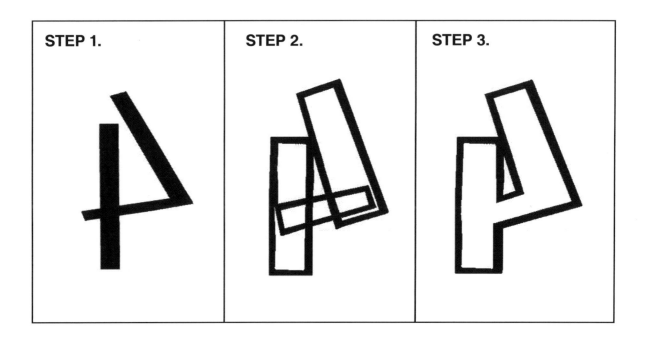

STEP 1. STEP 2. STEP 3.

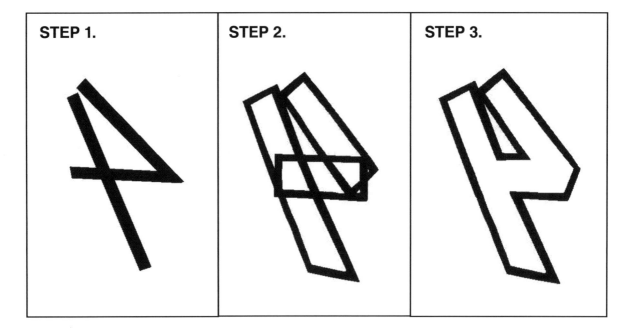

STEP 1. STEP 2. STEP 3.

Building letters with bars works well with any style of letters. Get into the habit of using bars to form your letters and it will become easy for you to do. Practice, practice, and then practice some more. You will see how valuable this letter building technique is for letter modification in the next section of this book.

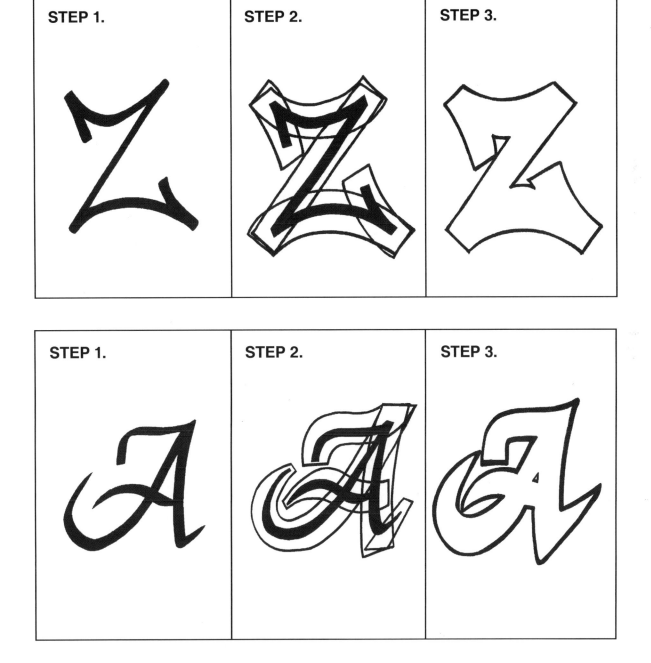

STEP 1.

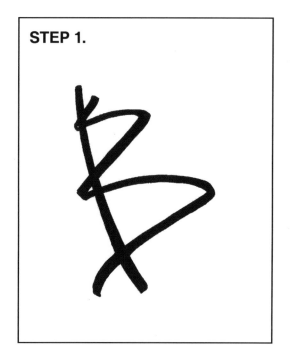

STEP 2.

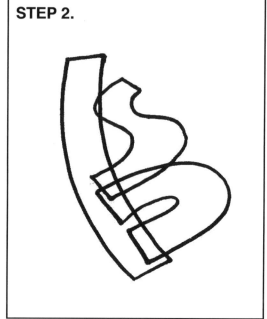

STEP 3.

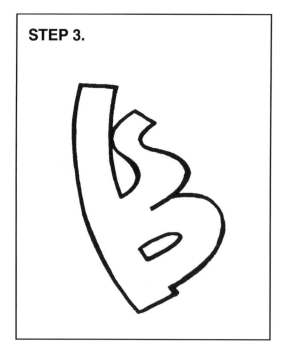

Bars can be used to build any style of letters. Building letters with bars combines all of the different techniques we have covered so far.

BUILDING BUBBLE LETTERS WITH OVALS

One final thought on building outline letters. This is a variation on forming bubble letters. It is similar to building letters with bars, except that in this method you will be surrounding the strokes of your letters with ovals. Where you have curved strokes, like in a "B" or a "C", you can form the curve with several small ovals strung together. The edges of the ovals overlap to form the outline of the letter. The point we most want to convey in this first section of this book is that you can use any or all of the different techniques we've covered so far to turn your letters into outline letters. Combine them if you like. Practice as much as you can until you feel confident. Draw lightly and sketch out your letters in whichever way is easiest for you. Bubble letters are the most popular style of outline letters and are a great place to start your graffiti training. Experiment with this technique and then move on to Section Two on letter modification.

STEP 1. Draw a basic "A" with a pencil.

STEP 2. Draw ovals around each stroke of the letter "A". You should have 3 ovals.

STEP 3. Draw a dark line all around the outside edge of the letter. Erase the inside guidelines and add a few small details inside to make the letter look rounded and puffy.

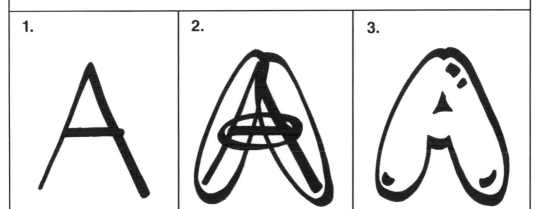

Here are the letters "B" and "C" also formed with ovals. Follow the steps. You can draw the rest of the alphabet in the same way using a combination of big and small ovals. Use as many ovals for each letter as you want. Refer back to the chapters on bubble letters and block letters to help you along.

STEP 1. Draw a basic "B" or "C" with a pencil.

STEP 2. Draw ovals around each stroke of the letter. In the "B" and "C", break your curved lines into segments and draw several smaller ovals overlapping on the edges.

STEP 3. Draw a dark line around the outside edges of the letters. Erase the inside guidelines and add a few little details to make the letters look rounded and puffy.

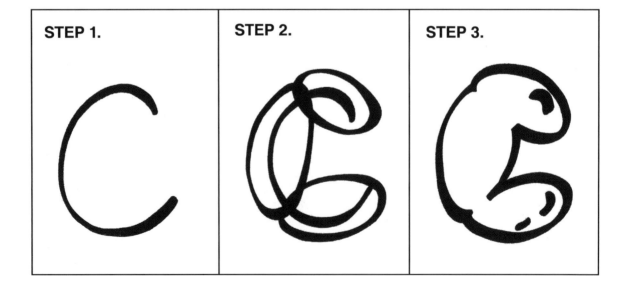

STEP 1. STEP 2. STEP 3.

STEP 1. STEP 2. STEP 3.

You can use ovals the same way you use bars with any style of letters to form outline letters. This style below is called "soft bars". Soft bars are a more sophisticated style of bubble letters. The rounded, long, skinny bars are a combination of bars and ovals. They are very flexible and can be molded around any letter stroke or shape. These are our personal favorite style of letters.

STEP 1.

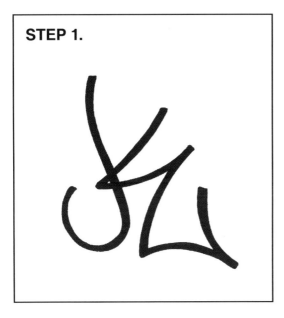

STEP 2.

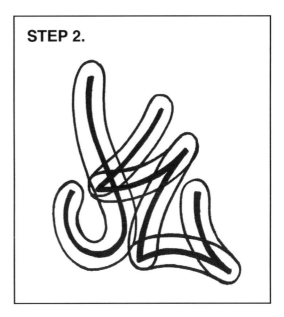

STEP 3.

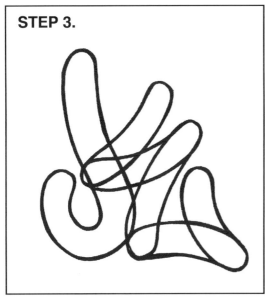

STEP 4.

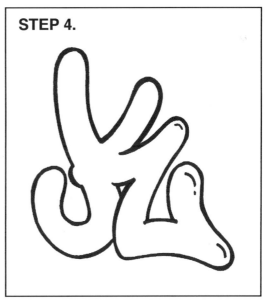

Try combining the techniques you have learned so far in different ways to find a style of letter formation that works best for you. Practice and watch your confidence grow.

SECTION TWO

LETTER MODIFICATION

Now you are ready to modify your letters into graffiti style letters. This is accomplished by distorting the shapes and movements of bars and then adding ornaments. No matter which style of letter you are working with the techniques for modifying them are basically the same. Here is a sample list of some of the styles of modified letters invented by graffiti artists over the last 40 years: wildstyle, semi-wildstyle, computer rock, soft bar, mechanical, and platform to name just a few. All of these styles are based on transforming basic Roman letters (A,B,C,D,F,G, etc…) into elaborate new forms. The one thing all of these styles have in common is that no matter how much a letter is distorted, reconstructed, transformed, or modified, the basic structure of the letter remains intact. In other words, an "A" still looks like an "A". You can still read it as an "A" no matter how modified it is. This is known as maintaining the structure of the letter and it is the foundation of graffiti lettering.

This is a book for beginners, so in the spirit of keeping it simple we will refer to all of the modified graffiti letters we work with in this book as wildstyle letters. Wildstyle letters are defined as complex, interlocking letters with extensions, arrows and other decorative elements. Wildstyle letters are a unique invention of graffiti artists.

While there are no hard and fast rules, there are some tried and true methods for reconstructing and modifying letters that will result in exciting, unique wildstyle letters. You can use some or all of these methods to modify your own letters. The methods are as follows:

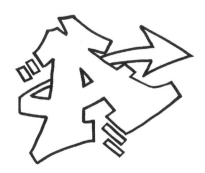

1) BENDING BARS
2) ADDING ARROWS
3) ADDING EXTENSIONS AND BITS

Here are some of the
wildstyle letters we will
show you how to build
in this section.

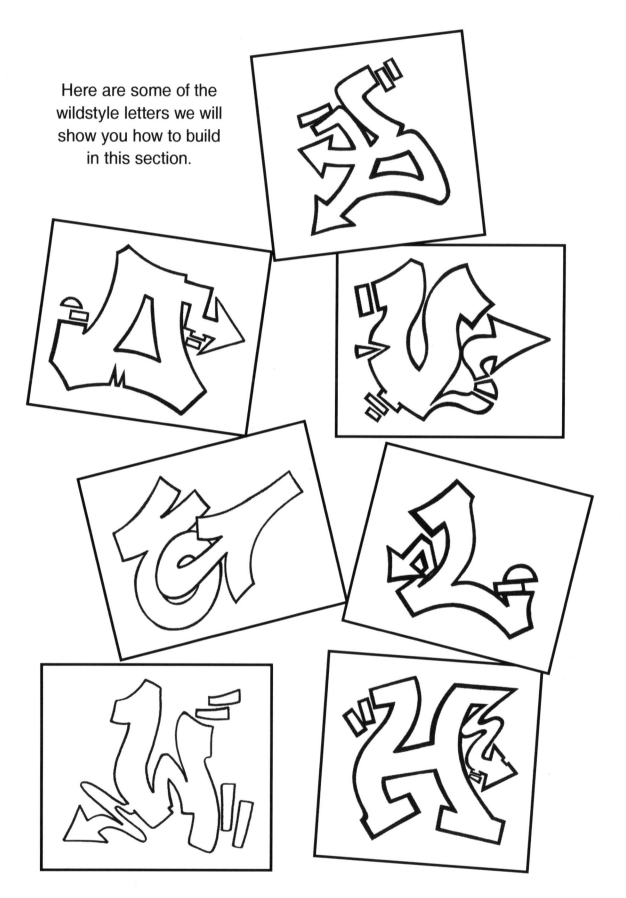

CHAPTER ELEVEN
BENDING BARS

Let's examine the different techniques of letter modification more closely. We'll start with the method of bending bars. Bending the bars of a letter alters its basic framework. Altering the framework means that the bars that surround the strokes of a letter can be stretched and distorted to form new shapes. Think of the bars as being made out of a flexible material like rubber. You can stretch, squeeze and pull on any section of a bar to change it. Keep in mind that the structure of the letter needs to remain intact. Once you master this technique, you will see that graffiti letter modification is a fluid process that makes it possible to transform letters into all kinds of unique new shapes and styles. Follow the basic steps in the diagram below starting with a straight letter "A". Then turn to the next page to see how to bend the bars to modify this letter "A".

STEP 1. Draw a basic letter "A" lightly with a pencil.

STEP 2. Draw bars around each of the strokes. Make the top corners very close together.

STEP 3. Erase the inside guidelines. You now have 3 bars that you can bend in any way that you like.

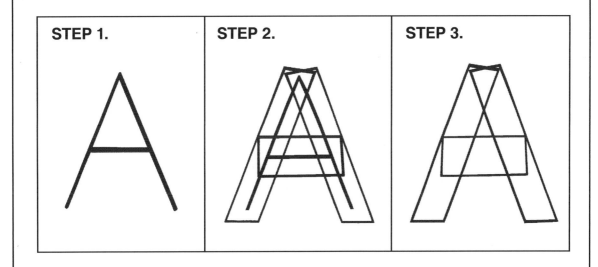

| STEP 1. | STEP 2. | STEP 3. |

Now bend the bars. When we say bend, we mean bend-d-d-d-d. Take
the three bars and individually bend them. Like this…Follow the steps.

STEP 4.

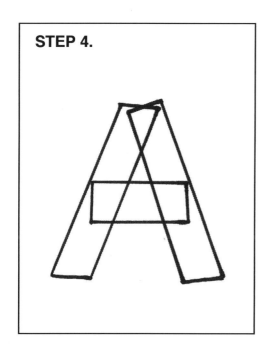

STEP 5.

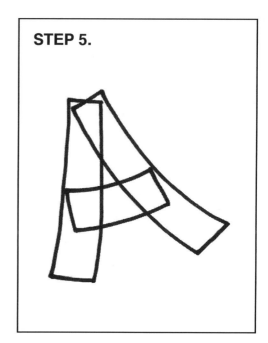

STEP 6.

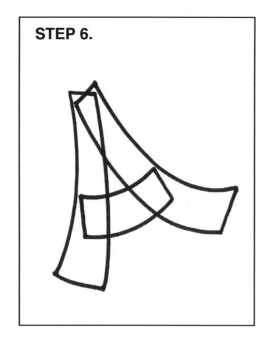

STEP 7.

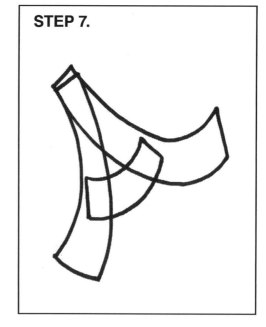

Once you have bent the bars as much as you want, you can add other details. It doesn't take that much work to make this letter "A" into a graffiti letter. Just bend the bars and add some small bars on the top and bottom for serifs. You can also make some of the bars thinner, like the crossbar of the "A". Then extend it slightly on either side. Draw a dark line all around the outside edge and erase the inside guidelines. This is your finished wildstyle letter "A".

STEP 1.

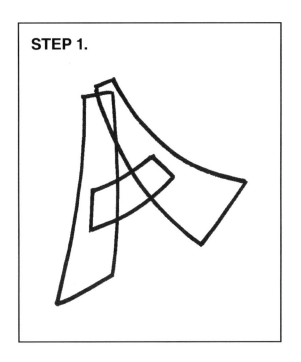

STEP 2.

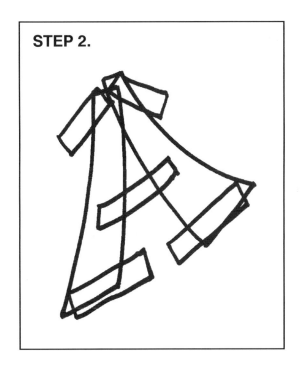

STEP 3.

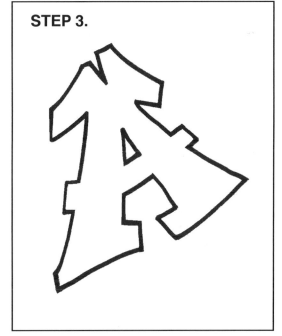

You can bend the bars however you want. You can change the size of the bars. Add extra bars. Break a bar into segments. Stretch or squeeze the bars individually or all at once. Flare out the ends. Make them jointed. The only rule you have to follow is that no matter how much you bend and distort the bars, the resulting form still has to have the structure of a capital letter "A".

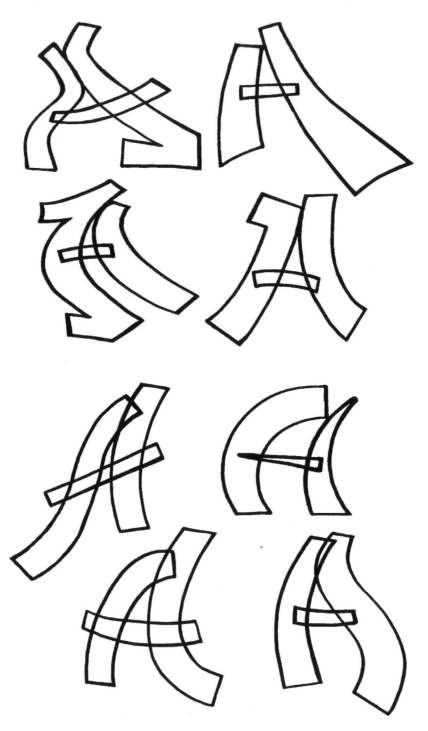

There are, of course, thousands of variations on any letter.
Remember - maintaining the structure of the letter is the key. Notice that all of these variations still look like the letter "A". Try to nvent some of your own variations. Exaggerate the bending as much as possible.

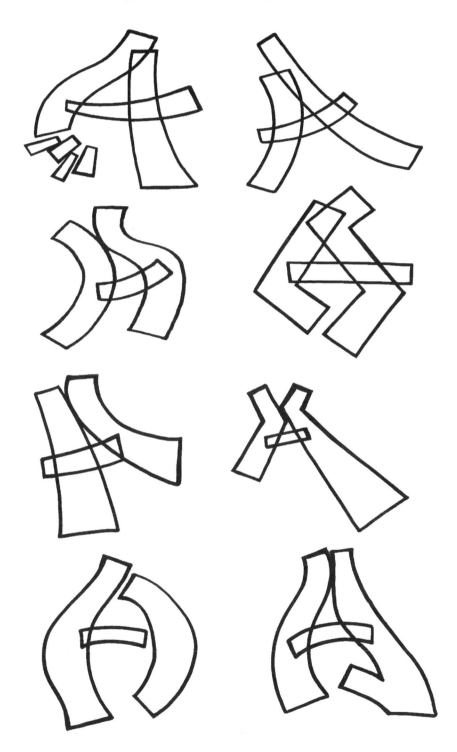

Naturally if you start building your letter with a tag letter, the bars of the letter will already be bent.

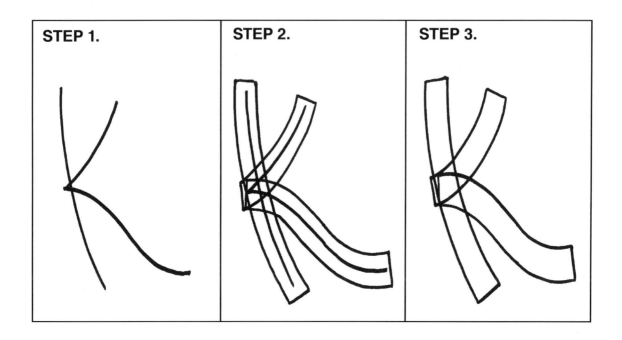

But you can continue to modify and bend the bars even more, like in these variations below.

Choose a variation that you like, then add small bars for serifs and redraw your finished letter.

By now you should be starting to get the idea of how this system works. If not, just keep going. You will get it eventually.

STEP 1.

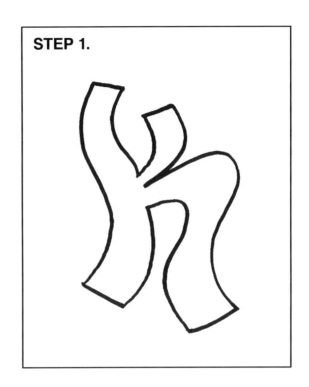

STEP 2.

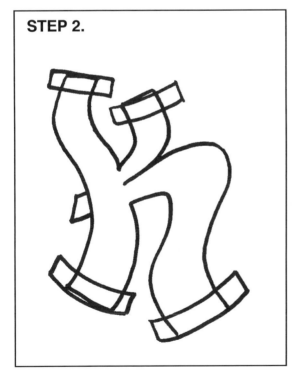

STEP 3.

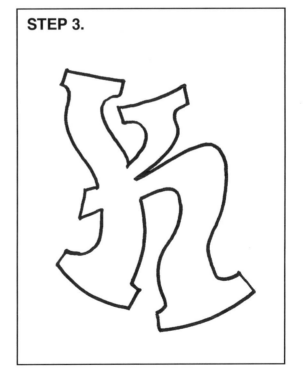

Here is an example of one variation of a whole alphabet drawn with a combination of bent and straight bars. It is up to you to decide how many bars to use in each letter and how to shape the bars. Experiment with different variations. Copy some of these letters below and then try bending and modifying them in your own way.

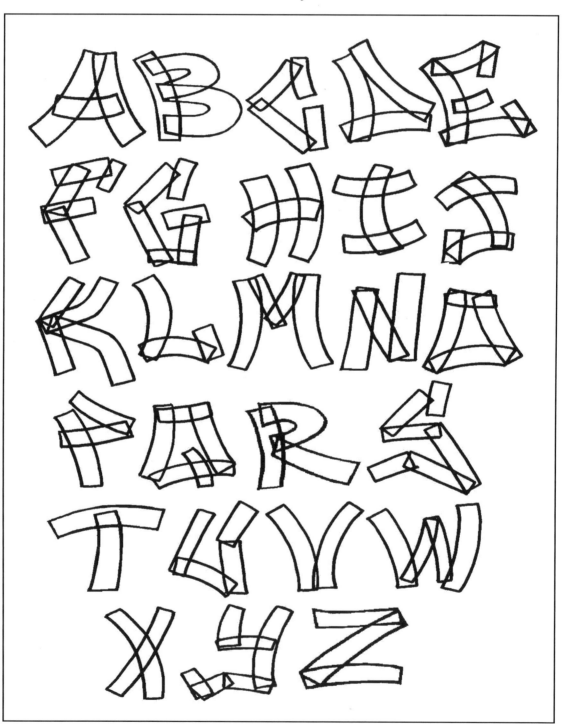

Choose one letter and try bending the bars even more. If you don't like the way we formed the letters on the previous page and you know a better way, by all means change it and fix it the way you think it should be. There is no exact method to doing this. And definitely no shortcut. You have to draw letters hundreds of times to really learn this technique. It sounds like a lot, but think about how many zillions of times you have written your name over your lifetime. Graffiti is just a different way of writing and a new way of thinking about the letters of the alphabet. In graffiti, letters are *artful*.

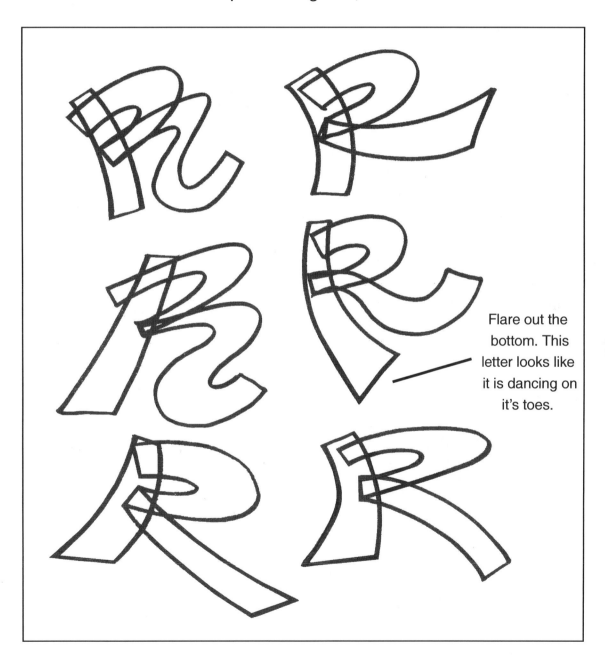

Flare out the bottom. This letter looks like it is dancing on it's toes.

If you get stuck for ideas and need inspiration, just go back to tag letters. Find some tag letters in a book or on the internet and copy them a couple of dozen times. Then go back and try sketching bars and bending them. This will definitely kickstart your letter drawing. Remember that graffiti art started with tags. Tags are where all the action is!

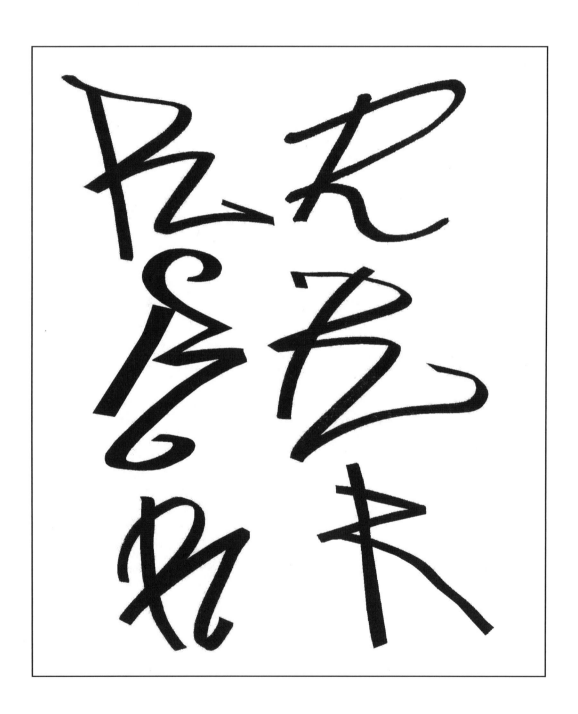

CHAPTER TWELVE
HOW TO DRAW GRAFFITI ARROWS

Arrows point! Like a one way sign on a street corner. That's it, that's what they are for. But in graffiti art arrows are so much more than that. They are a unique aspect of this art form. In fact we would argue that arrows are the most important element of graffiti art. But how did that develop? Where did it come from?

If you look at early tags from the 1970's you'll get your answer. Graffiti writers began to incorporate arrows into their tag letters very early on. An arrow gives a tag its personality and individuality. It makes a statement. It says "LOOK AT THIS TAG!" Arrows express movement and energy. Arrows can be drawn as a natural extension from the end of the stroke of a letter, like in the letter "e" below. Or an arrow can be added seperately as an embellishment to underline or accent a name. Wherever you look in graffiti art you find arrows. Learning how to draw them will make your letters exciting and dynamic.

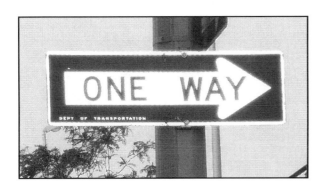

Arrows indicate direction. They guide the eyes of the viewer in a particular direction.

Adding arrows to your letters will give them power and energy.

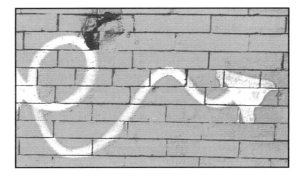

Here are some examples of tag letters with arrows. Notice how the arrows flow smoothly from the ends of the strokes of the letters. This is where the concept of graffiti arrows started.

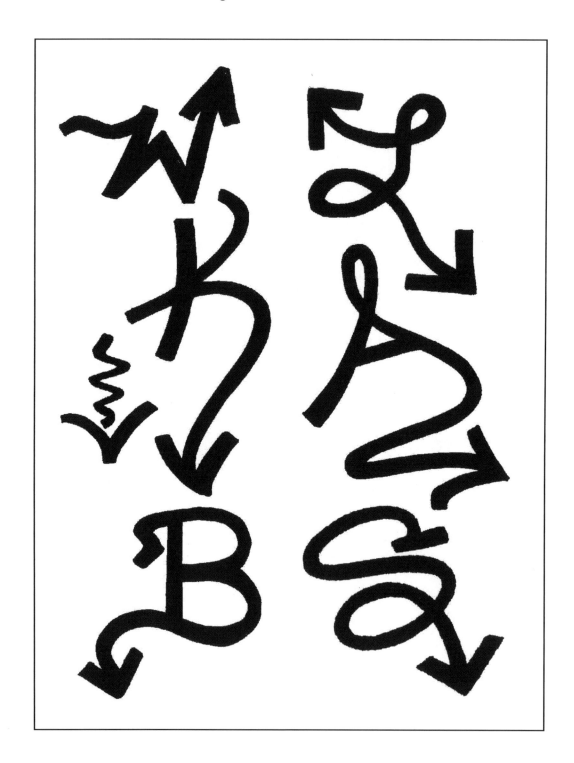

Try this shortcut crayon method to turn a tag letter with an arrow into an outline letter. This method is similar to building with bars, because you will be fattening up the letters into outline letters without changing the shape or design of the letters you are starting with. This technique works with any style of letters. It is a fast and easy alternative to building letters with bars.

STEP 1. Draw any letter that you want with an arrow on the end. We have drawn a tag letter "E".

STEP 2. Take a dark colored crayon, break off a small piece (about 1 inch), and peel off the paper. Draw over your letter using the flat side of the crayon, following the shape of the letter. If you want your finished letter to be fatter use a bigger piece of crayon.

STEP 3. Draw a dark outline all around the outside edge of the crayon line. You can draw the outline with a pencil, crayon, marker or pen.

STEP 4. Put a clean sheet of paper on top and trace only the outline of the letter. Make it crisp and sharp.

STEP 1.

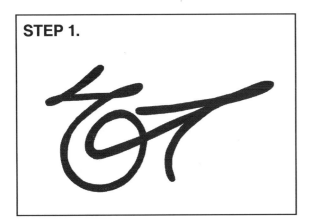

STEP 2.

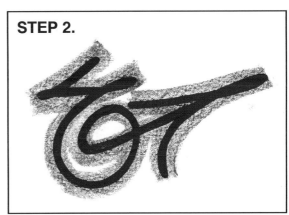

STEP 3.

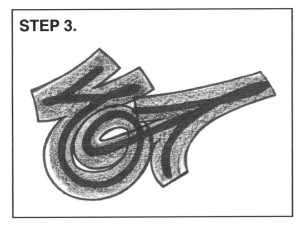

STEP 4.

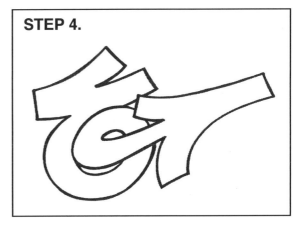

Here is the shortcut crayon method with a tag letter "S" with an arrow. The finished outline letter becomes a good foundation on which you can build a more complicated letter later on. We added some extra details in Step 4 below to demonstrate the possibilities.

STEP 1.

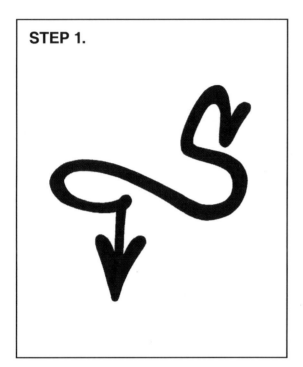

STEP 2.

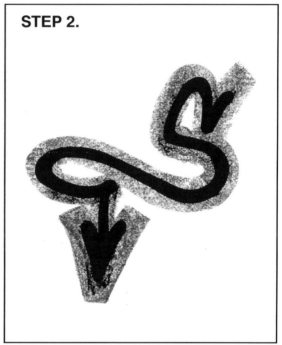

STEP 3.

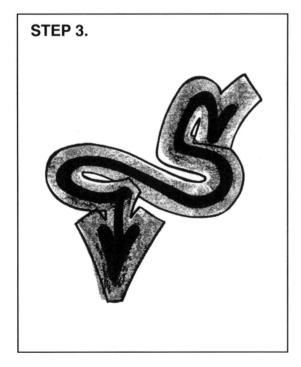

STEP 4.

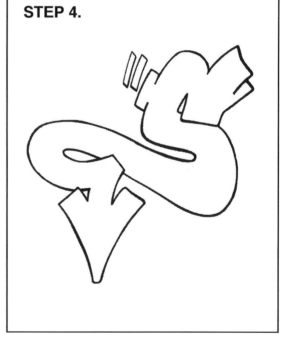

HOW TO CONSTRUCT A BASIC ARROW

STEP 1. To create an arrow, start by sketching two parallel lines lightly with a pencil for a stem.

STEP 2. Draw a baseline across the top of the 2 lines as wide across as you want the arrow to be.

STEP 3. Draw a center guideline. Make it as long as you want the arrow to be when it's finished.

STEP 4. Connect the points to form the head of the arrow. Draw a dark outline around the outside edge and erase the guidelines. This is your finished basic arrow.

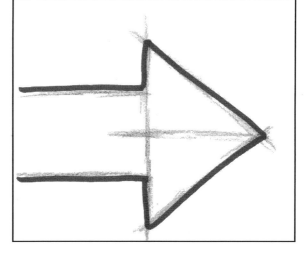

TRY THESE STYLIZED ARROWS

STEP 1. Draw a second baseline, but this time draw it as a curved line.	**STEP 2.** To finish this arrow, draw a dark line around the outside edge. Erase all of the unnecessary guidelines.

SECOND BASELINE

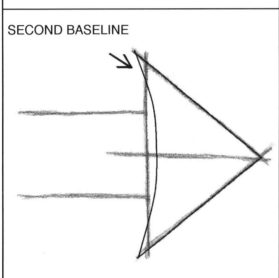

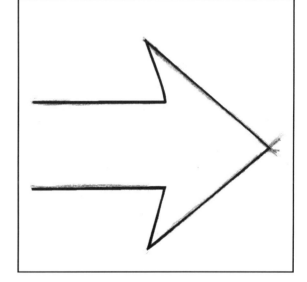

TRY CURVING THE ARROW UP OR DOWN BY BENDING THE GUIDELINES

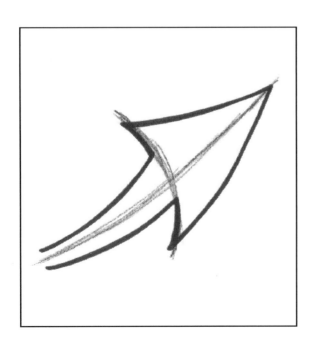

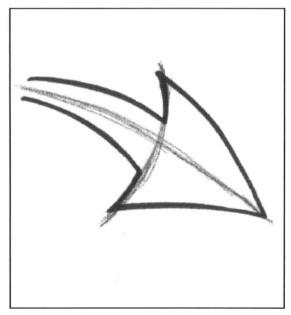

You can draw arrows in any shape that you like. Here is an assortment of popular graffiti style arrows. Throughout the rest of this book, we will demonstrate how to add some of these arrows to your letters, but for now practice drawing them as they are with the ends open.

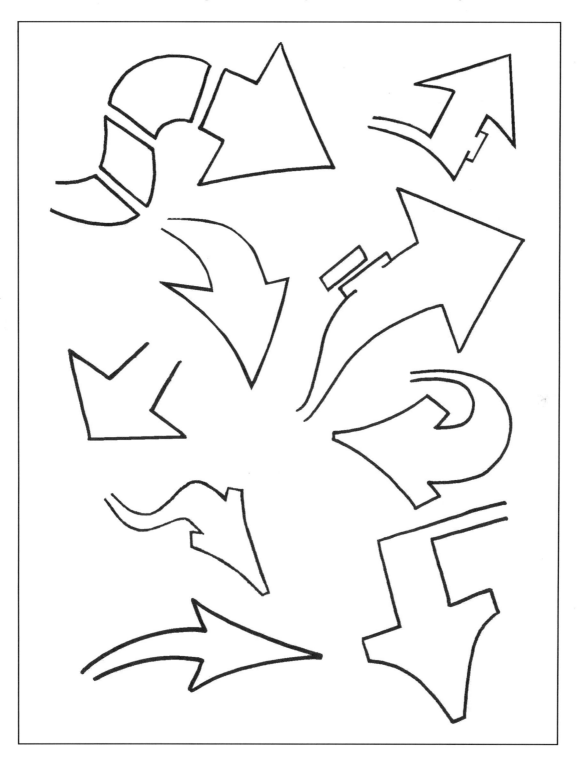

You can attach an arrow to any part of a letter. Just draw a line with an arrow point protruding off the side, then use bars to fatten it up, and redraw the finished letter. Draw the head of the arrow in any shape that you want.

STEP 1.

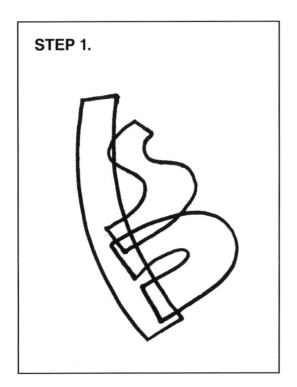

STEP 2.

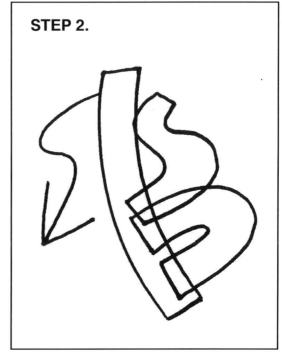

STEP 3.

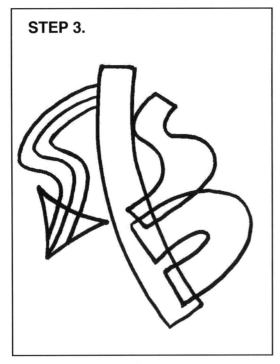

STEP 4.

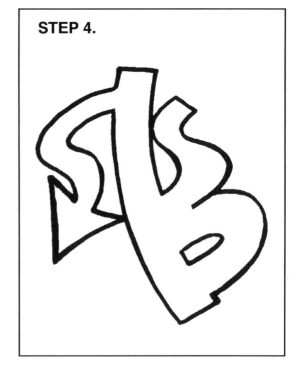

Extensions are extra bars or stretched out parts that are added to a letter after you lay out the basic shape. Adding extensions allows you to transform or modify a letter into an even more complex or abstract form, while still retaining its original structure. Although graffiti artists use a variety of categories to classify different types of extensions, we will refer to them all simply as extensions. An extension can flow naturally from the main body of a letter in a similar way that a stroke in a tag letter curves, flows or twists. (Remember that graffiti is derived from tags.) An extension can loop around, overlap or bounce off of the main body of a letter. Or an extension can jump sharply off the side of a letter in a pointed, angular pattern. Extensions typically flow from the end of a serif, but they can protrude from the side of a letter as well. Experimentation is the key to creating extensions that are balanced and visually pleasing. Placing an arrow at the end of an extension increases its energy and movement.

This example of a wildstyle "M" has many different styles of extensions. Notice that they are just extra parts added to the main body of the letter. We will show you how to construct this letter in detail in the next chapter.

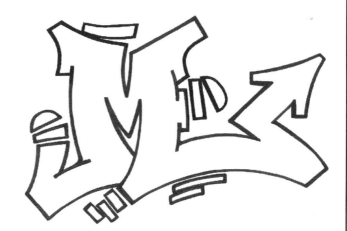

Any letter can have extensions, which can be drawn in all shapes and sizes. You can form an extension by stretching out a serif into a long bar. Then bend the bar at an angle and add an arrow to the end. Adding extensions to a letter is the creative part of graffiti lettering.

You can add as many extensions to a letter as you want anywhere that you want. With practice and patience, you will learn to know what makes sense and what looks balanced and what doesn't work. Think about the movement and expression of the letter you are trying to draw.

You can slice an extension into segments and form bits. Bits are small slices that are chipped off of different parts of a letter. They can be placed at the ends of an extension or break off the end of a stroke as a finishing touch. They can be drawn as individual pieces or groups alongside any portion of a letter. They can be placed at breaking points in a line. Bits make a letter look like it is disintegrating and breaking apart. They can be added as a counterweight to an arrow protruding from the other side of a letter to create balance. No matter where you put bits they add complexity and breathe life into your letter. They can be drawn in any shape, but are usually drawn as small rectangles. Once again, practice is key. In the box below are some examples of popular styles of extensions and bits. We will demonstrate how to use extensions and bits in more detail in the next chapters.

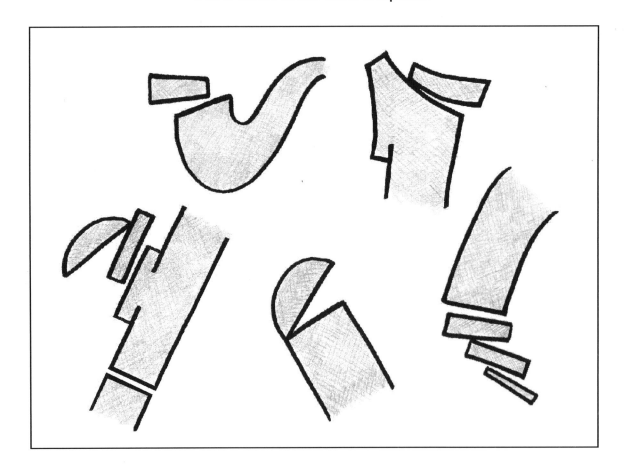

BLENDING AND DEFINING LETTERS

Now you are ready to combine all of the different pieces and parts into a finished wildstyle letter. This stage is where you begin to add expression and character to your letter. Drawing lightly with a pencil is really helpful, because you can erase all of the unneeded guidelines that you use to build your letter. Or you can draw with a pen or marker and just trace your new drawings onto clean sheets of paper as you move from one step to the next. Experiment and see which way works best for you. We begin this exercise with a capital letter "M" with bars that are already slightly bent.

STEP 1. To start, draw a letter "M" with bent bars. This is the foundation that you will build upon. Then think about the letter you want to create. How does it move? How does it stand? What kind of attitude does it have? What kind of style? Think about the overall shape of the letter you are going to draw.

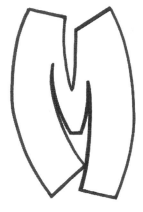

Bars are bent slightly on both sides

STEP 2. Next, sketch in small bars to form serifs at the top and bottoms of the main strokes. This stage of letter development is where style comes into play. Remember to think about the action and movement you want your letter to have, and the expression you want it to convey. Try to make the serifs a little chunky.

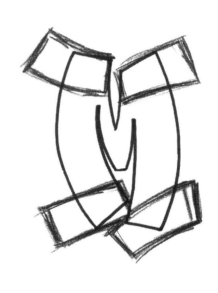

STEP 3. Draw a dark outline all around the outside edge, molding and stretching the lines in and around the serifs. Blend all of the different parts so that they work together as one continuous piece. Don't worry about details yet. Just think about the shape and the expression you are trying to convey as you sketch out the lines. Pay special attention to the structure of the letter. The "M" should still look like an "M", no matter how much you stretch and bend the lines.

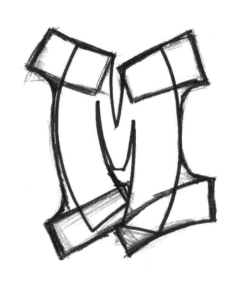

STEP 4. Now, lightly sketch in more elements. Here's where you start fleshing out the finished form. Make the bottom serifs into long and short extensions. Add an arrow on the right. Draw a small bar along the right side for an extension and add 2 bits next to it. Add more bits. Don't worry about making it neat. Just sketch lots of lines and try different things.

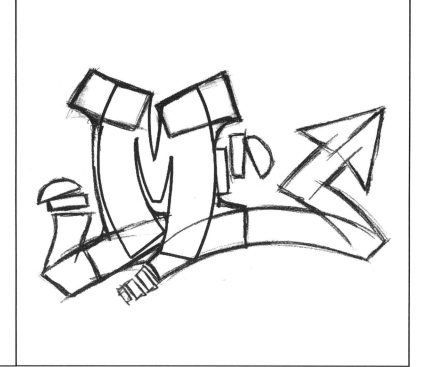

STEP 5. Reshape and extend the top serifs however you want. Add a long bit on the top. Add two long bits along the bottom. Reshape the ends of the arrow. It's kind of like sculpting the lines with your pencil. When you think the letter is done, blend together all of the outside edges of the new lines and the old ones to form the final shape.

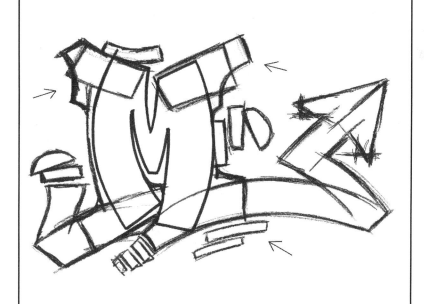

There is no right or wrong way to do this. Just experiment.

STEP 6. At this stage, you can begin to define your lines. Decide which lines are going to be in the final drawing. Then darken those lines with a marker or a pencil. Draw a dark line all around the outside edge of the letter and erase all of the unnecessary guidelines. You can trace the finished letter onto a clean sheet of paper. Make the edges sharp and clean. This is your finished wildstyle letter, complete with extensions, an arrow, and all kinds of interesting bits!

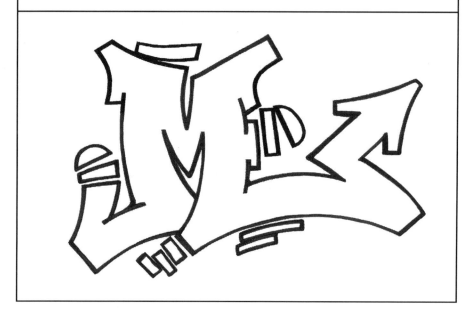

The number of steps that it takes to get to the finished letter doesn't really matter. The process is what you should focus on. Just think about what kind of letter you would like to create and experiment with lots of different ideas until you get to a finished design that you are happy with. Sketch lots of lines and erase them as needed.

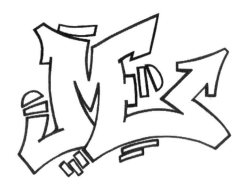

Here's an interesting variation: elongate the top, right serif to form a letter "E" and this letter "M" becomes the word "ME". This idea came from one of our students, Jill. Really smart concept. You never know what great ideas other people will have.

DRAWING WILDSTYLE LETTERS - LETTER PROGRESSION

Learning to draw wildstyle letters takes lots of practice and eventually you will begin to get a feel for where elements and details can be added. You can combine bent bars, arrows, extensions and bits to create an infinite number of variations. On the following pages we present a collection of finished letters in different styles with their step-by-step breakdowns, so you can see how they progress from basic letters into wildstyle letters. Copy these examples for practice. The idea is to get you used to constructing letters in this way. Try to invent some of your own letters in a similar way.

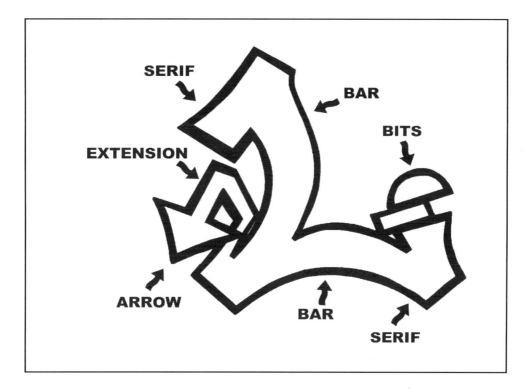

Another term for letter modification is **letter progression**. It simply means that a letter progresses from one form to another in a series of steps.

LETTER PROGRESSION EXERCISES

Once you settle on the basic form for your letter, you can begin to add whatever ornaments you like. Follow the steps below to modify a basic letter "L" into a wildstyle letter "L".

STEP 1. Start by drawing a capital "L" with a pencil.	**STEP 2.** Draw a bar around each stroke. Overlap the edges of the bars.	**STEP 3.** Erase the inside lines of the "L".

STEP 4. Now bend the 2 bars.	**STEP 5.** Draw a small bar at the top and a small bar at the bottom to form serifs. Draw a long, angled extension and an arrow on the left side.	**STEP 6.** Draw a dark line all around the outside edges of the letter blending all the lines. Draw 2 small bits on the right side. Erase the inside guidelines.

STEP 1. Start by drawing an "A" with a pencil.	**STEP 2.** Draw a bar around each stroke and overlap the edges.	**STEP 3.** Erase the inside lines of the "A". You should have 3 bars.

STEP 4. Now bend the 2 vertical bars in several different places. Bend the horizontal bar.	**STEP 5.** Draw 2 smaller bars at the top and 2 at the bottom ends of the vertical bars to form serifs. Then draw a long, angled arrow coming off the end of the bar on the right.	**STEP 6.** Draw a dark line all around the outside edges of the letter, blending all the lines. Draw 2 bits on the left side and 2 bits on the right side. Slice the arrow into pieces. Erase the guidelines.

STEP 1. Start by drawing an "H" with a pencil. You should have 2 vertical strokes and one horizontal stroke.	**STEP 2.** Draw a bar around each stroke. Overlap the edges of the bars.	**STEP 3.** Erase the inside lines of the "H". You should have 3 bars.

STEP 4. Now bend the 2 vertical bars and bend the horizontal bar slightly upwards.	**STEP 5.** Draw smaller bars at the top and bottom ends of the vertical bars to form serifs. Then draw a long, curvy arrow coming off the end of the serif on the right side.	**STEP 6.** Draw a dark line all around the outside edges of the letter, blending all the lines. Draw 2 small bits on the left side. Erase the inside guidelines.

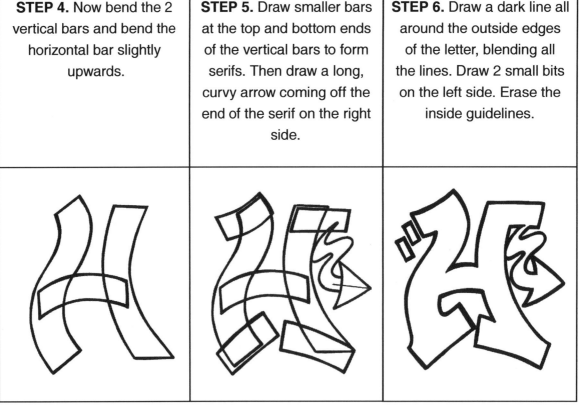

On curved letters like "C", "O", "S", etc, you can break your curved lines into as many segments as you like.

STEP 1. Start by drawing a "C" with a pencil.	**STEP 2.** Draw bars around the strokes. Break the curve of the "C" into segments and draw several small bars. Overlap the edges of the bars.	**STEP 3.** Erase the inside lines of the "C".

STEP 4. Now bend each of the bars. Stretch and modify them as needed.	**STEP 5.** Draw small bars at the bottom to form a serif. Draw a long, angled arrow coming off the left side with a tiny extension and a bit. Draw a small bar on the top of the upper serif.	**STEP 6.** Draw a dark line all around the outside edges of the letter, blending all the lines. Draw 2 small bits on the right side. Erase the inside guidelines.

STEP 1. Draw a square shaped "O" with a pencil. You should have 2 vertical strokes and 2 horizontal strokes.	**STEP 2.** Draw a bar around each stroke. Overlap the edges of the bars.	**STEP 3.** Erase the inside lines of the "O".

STEP 4. Now bend all 4 of the bars inward.	**STEP 5.** Draw a small bar on the bottom left side to form an extension. Then draw a long, angled arrow coming off the end of the top, right side. Draw a tiny extension and a bit.	**STEP 6.** Draw a dark line all around the outside edge of the letter, blending all the lines. Draw 2 small bits on the left side. Draw 2 small, triangular cuts at the bottom. Erase the inside guidelines.

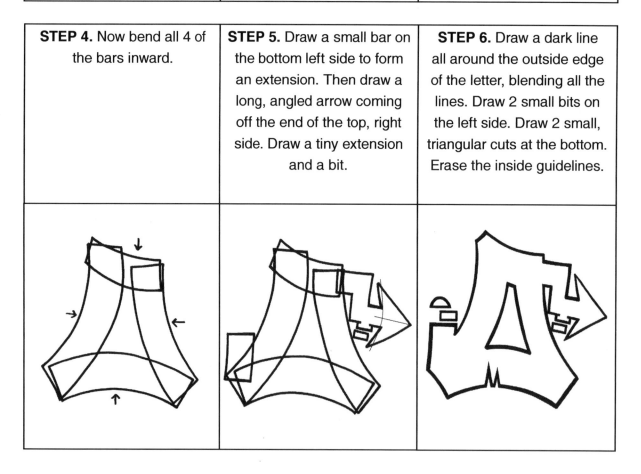

You can stretch or compress the bars as needed to give your letter lots of movement and expression.

STEP 1. Start by drawing a letter "B" with a pencil.	STEP 2. Draw bars around each stroke. Break the curved strokes into several segments. Overlap the edges of the bars.	STEP 3. Erase the inside lines of the "B".

STEP 4. Now really bend all of the bars in several different places. This is a more sophisticated letter with lots of movement. Study this step carefully.	STEP 5. Draw a small bar at the end of the top right stroke. Then draw an arrow coming off the top left stroke and an arrow coming off the bottom left stroke.	STEP 6. Draw a dark line all around the outside edges of the letter, and blend all of the lines. Draw 2 bits on the right side and 2 bits on the left side. Erase all the inside guidelines.

You can make your wildstyle letters really complex by adding lots of different ornaments, bending the bars as much as possible, and making interestingly shaped cuts and slices anywhere you like.

STEP 1. Start by drawing a capital letter "V" with a pencil.	**STEP 2.** Draw 2 bars around the strokes.	**STEP 3.** Erase the inside guidelines.

STEP 4. Bend the bars in several different places. Exaggerate the bends as much as you can. Make them really curvy and wiggly.	**STEP 5.** Draw small bars at the top for serifs. Draw a long curvy arrow on the bottom right side. Draw a small bar on the bottom left side for a small extension. Make a triangular notch and bit on the left side.	**STEP 6.** Draw a dark line all around the outside edges of the letter blending all the lines. Draw 2 small bits on the left side. Slice the arrow and top, left serif into segments. Erase the inside guidelines.

You can also start building a wildstyle letter with a tag letter. With a tag letter, the bars are already bent. Feel free to alter this method anyway you like - you can change the sequence or number of the steps.

STEP 1. Start by drawing a tag letter "R" with a pencil.	STEP 2. Draw bars around the strokes. Overlap the edges of bars.	STEP 3. Erase the inside lines of the "R".

STEP 4. Draw all around the outside edge of the "R". Erase all of the guidelines. Square off the corners of the bottom a little bit.	STEP 5. Extend the top stroke and draw an arrow on the end pointing upwards. Draw a long, curved extension at the bottom with a smaller bar on the end for a serif.	STEP 6. Draw a dark line all around the outside edges of the letter blending all the lines. Draw 2 small bits on the right side and 2 on the left. Erase the inside guidelines.

In this example, we use a mixture of ovals and guidelines to build a wildstyle bubble letter "S".

STEP 1. Start by drawing a tag letter "S" with a pencil. Draw an arrow at the bottom end.	**STEP 2.** Draw small ovals around the letter to fatten it up and make it into an outline letter. Overlap the edges of the ovals.	**STEP 3.** Draw an outline around the outside edge. Blend the lines. Erase the guidelines.
	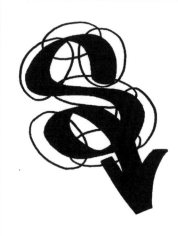	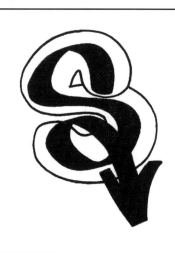
STEP 4. Draw small ovals around the stem of the arrow and the point to fatten it up, too.	**STEP 5.** Draw a dark line around the outside edges of the whole letter. Blend all of the lines together. Make the letter soft, round and bubbly.	**STEP 6.** Erase all of the guidelines. Add 2 bubbles on the right for bits. Add 2 little ovals for highlights inside the letter.
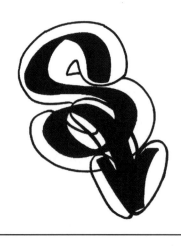		

STEP 1. Start by drawing a letter "W".	**STEP 2.** Draw 4 bars around the strokes and erase the inside lines. You should have 2 large bars and 2 smaller bars.	**STEP 3.** Bend the large bars and slide the left bar upwards and the right bar downwards. Bend the small bars inwards a little bit.
STEP 4. Draw all around the outside edges and erase the inside guidelines.	**STEP 5.** Draw 2 bars at the tops of the large bars for serifs. Draw a long curvy extension with an arrow on the end on the bottom left.	**STEP 6.** Draw a dark line all around the outside edges of the letter. Erase any unneeded lines. Add bits on the top and bits on the bottom right side.

STEP 1. Start by drawing a tag letter "F" with a pencil.	**STEP 2.** Draw bars around the strokes. Overlap the edges of the bars.	**STEP 3.** Erase the inside lines of the "F".

STEP 4. Draw small bars on the bottom stroke, middle stroke and top stroke for serifs.	**STEP 5.** Add more small bars on the ends of the serifs. Add an arrow on the left side with little extensions.	**STEP 6.** Mold and blend all the lines. Draw a dark line all around the outside edges of the letter. Erase all of the guidelines. Add 2 bits on the right side.

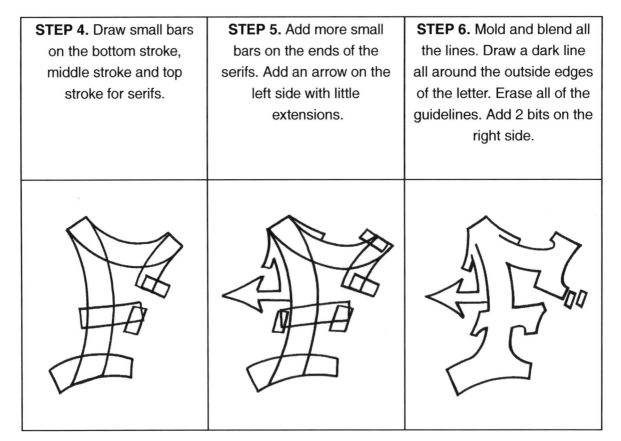

This is our final example for this chapter on wildstyle letters. Start with a tag letter "Z" and make your finished letter as complex as you can. Add or change any details that you like. The finished letter is enlarged on the next page.

STEP 1. Start by drawing a tag letter "Z" with serifs.	**STEP 2.** Draw bars around each stroke. Overlap the edges of the bars.	**STEP 3.** Erase the inside lines.

STEP 4. Draw a long curvy arrow and lots of bits. Add extensions and bits, following the diagram below.	**STEP 5.** Draw all around the outside edges and erase the inside guidelines. Draw rectangular cuts in the extensions. Mold and blend all of the lines together.	**STEP 6.** Draw more bits. Draw a seam in the middle. Slice out a chunk at the bottom and make a small bit in the same shape like a puzzle piece.

There is no end to the different ways you can deconstruct, transform or modify a letter, as long as you maintain the original structure of the letter that you started with. We hope we have demonstrated this concept clearly. Remember to bend your bars and exaggerate the movement! Some of your experiments may not be the most elegant at first, but with practice your letters will improve. You need to study lots of graffiti done by other people - that's what we do. We are still learning and striving to draw letters with more funk and attitude. Don't get discouraged if it seems difficult. Just keep at it - mastering this art form takes time. Focus on the letters and think about giving them motion and a personality, kind of like a cartoon character. Experiment and practice. In the next chapter we will show you a useful exercise that you can use to help speed up your progress.

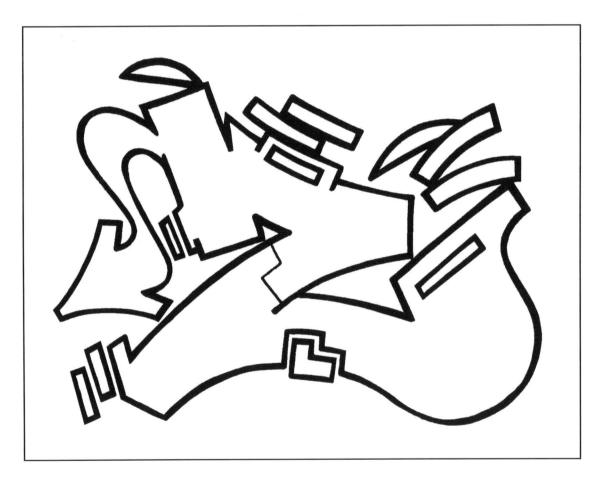

We just kept adding elements and ornaments to this letter "Z" to make it more intricate until it looked finished. Can you think of any more details to add?

CHAPTER SIXTEEN
REVERSE ENGINEERING A WILDSTYLE LETTER

You can turn letter progression backwards to deconstruct a letter created by somebody else. This exercise can unlock some of the mysteries of letter development. We call it "reverse engineering wildstyle letters". Reverse engineering is the process of discovering the principles of an object or system by taking it apart. So we are taking finished letters apart to understand how they were formed. In actuality, we are just guessing how a graffiti artist might have constructed a particular letter. But by devising a series of steps that lead from the finished letter all the way back to its basic form, we are able to imagine how it was constructed and use those tools to create our own original letters.

Of course, our goal is to teach you to draw your own letters: that's why we wrote this book. But graffiti is an intricate, complicated art form and you can use this exercise to decode it when you are just starting out. We use it all the time to break down and rebuild letters with interesting elements and complicated details. It is helpful and instructive to study the letters and styles of talented and accomplished graffiti artists. You can find all kinds of wildstyle letters on the internet and in graffiti books to give you ideas. Get used to drawing letters constantly. Turn to the next page to see our example for reverse engineered letter progression.

In this diagram you can see the finished wildstyle letter "N" on the left with all of it's added ornaments. On the right is the basic letter "N". It's amazing to realize that both of these examples are the same letter, "N", drawn in different styles. This is the magic of graffiti art.

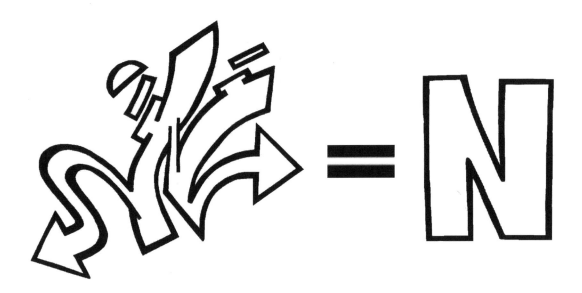

To do this exercise we will be stripping away all of the extra parts of the wildstyle letter. Then we will break it down into it's three essential bars. This exercise requires lots of thinking and brain work, but it can teach you a lot about letter structure and development.

NOTE: The more thought and effort you put into your study of graffiti letters, the more skilled and accomplished you will become.

Copy this example. Then find a letter that you would like to reverse engineer and break it down in the same way as this letter "N" below.

STEP 1. Start by drawing a wildstyle "N".	**STEP 2.** Remove all of the arrows, extensions and bits. Then break your letter into 3 bars.	**STEP 3.** Begin to spread the bars out and straighten them out a little.

STEP 4. Continue straightening the bars so that they become upright and vertical. You are actually un-bending them. Square off the corners of the bars.	**STEP 5.** Stretch the middle bar so that it reaches from the top-left to the bottom-right of the vertical bars. Make the 3 bars into evenly drawn rectanges.	**STEP 6.** Draw a dark line all around the outside edges of the letter. Erase all the inside guidelines. This is your finished basic "N". Reverse the steps to reconstruct the wildstyle letter "N".

Wildstyle is the most complex and hardest type of graffiti lettering to create. However, if you can deconstruct and decode a particular letter, you should be able to form similar letters by applying some of the design principals you discovered in the architecture of the original letter. It sounds a bit complicated, but remember, we are looking for ways to help decipher and demystify how graffiti wildstyle letters are constructed so we can form great letters of our own. This art form was established long before we came along and we have a lot of catching up to do. For some people it comes natuarally, for others it's a struggle.

Remember to bend your bars, add arrows and extensions, and maintain the structure of your original letters. It takes time and patience to learn to draw great graffiti letters, but eventually with practice you will be a pro.

CHAPTER SEVENTEEN
HOW TO BEND BARS USING CUTOUTS

This exercise is posted on our website and we've gotten so much positive feedback that we thought we should just mention it here.

This is a great exercise to help you understand bar bending. You will need a few sheets of card stock and some paper fasteners. This exercise is really helpful for people who need to physically bend bars in real life in order to understand the concept. These step-by-step instructions are easy to follow and will get you started drawing great wildstyle letters, especially if you are stuck like we were when we first started years ago.

STEP 1. On 2 or 3 sheets of 81/2"x11" card stock, draw several horizontal lines that are different widths. Make them from 1" to 2 1/2 " wide. Cut them out. There are no set rules, just make a few strips of different sizes. Here's a diagram to give you an idea what we mean.

STEP 2. Now cut the strips into different lengths. Again there are no set rules, just make them a few different lengths.

STEP 3. Take another blank sheet of card stock and cut out some triangles. These will be the tops of your arrows.

STEP 4. Take some paper fasteners and attach the strips end-to-end. Make some that are 2 pieces long and some that are 3 pieces long, etc. Here's a photo of the fasteners and some strips attached end-to-end to create joints. Make a whole bunch of these with big strips attached to little strips, etc. Leave some single strips as well. There is no exact rule, just make them up as you go.

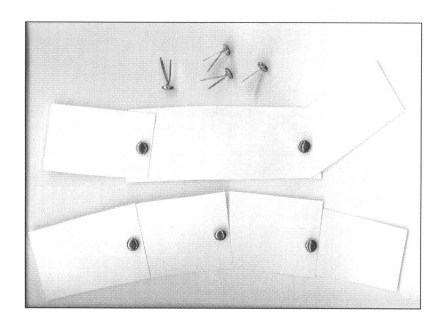

STEP 5. Now, take a few of the strips and form them into the letter "A", like we did in this diagram. You can just lay the pieces down on a table so you can manipulate them - you don't have to attach them.

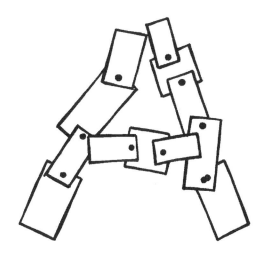

STEP 6. Then bend the strips at the joints to modify the letter. Bend them any way that you like. Try it a few different ways. Don't be afraid to take risks and really exaggerate the bending - it's only paper strips. Remember to always keep the structure of the "A" the same, so that it still looks like a letter "A". Try lots of different variations, like in the diagram below.

STEP 7. After you've experimented with a few variations, pick any one that you like. Then add a couple of single strips to form extensions on the ends or sides of the bars. Add a triangle to form an arrow. Add some bits. Your letter will begin to resemble an authentic wildstyle graffiti letter "A". Here is the letter "A" made with strips on the left and an outline drawing of the finished "A" on the right.

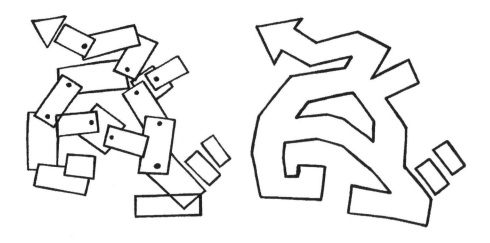

You can take photographs of the different arrangements as you lay them out. Then download them to your computer, print them and trace over the outlines. Or you can just copy them by eye. Keep your drawings or photos in a file that you can refer to for ideas.

Try lots of different letters and variations. Here is the letter "L" formed with strips and a finished outline drawing of the "L".

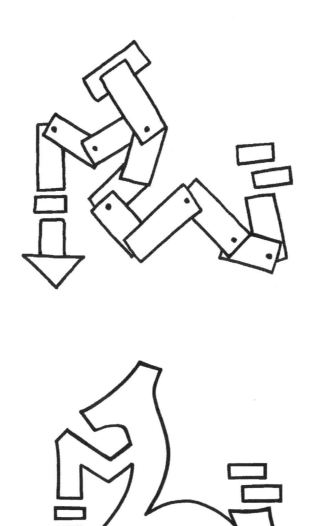

And here are a few examples of the letters "M", "G", "V", "R", and a lowercase "a". This exercise really helped us to grasp the concept of bending bars and now of course we can do it automatically, but in the beginning it was a challenge. When you are done, you can store your strips away for future use.

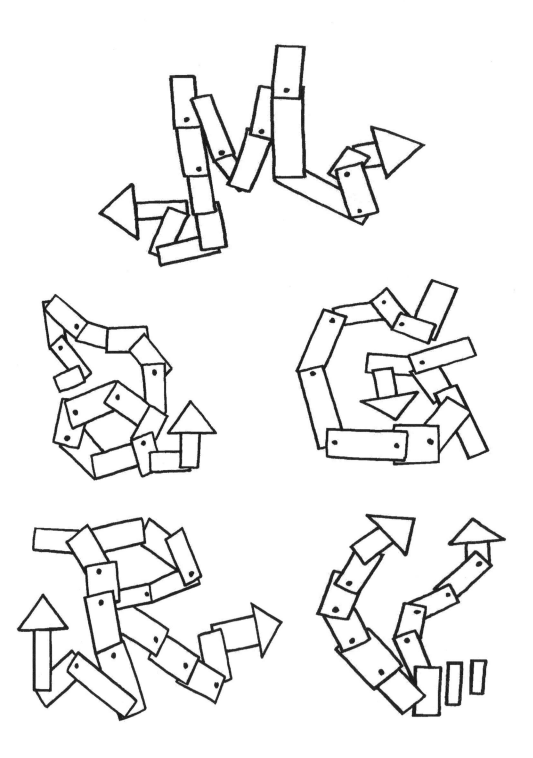

CHAPTER EIGHTEEN
LETTERS ARE ENERGY

WAIT! Before we end this section on letter modification we want to make one final, important point. At the beginning of this book we said that there are three basic styles of letters on which graffiti letters are based. But through the process of letter modification we begin to see how fluidly letters morph back and forth between all of the different styles - to wildstyle - tag - block - bubble - and so on. Imagine that a letter is made out of a ball of energy that you can stretch, mold and compress between your two hands into any shape that you want. That is how we see graffiti lettering. It turns out that all three letter styles are essentially the same, because the principals and rules used to transform them from standard Roman letters into new, fantastical styles are interchangeable. The rest of this book will focus on constructing whole words, names and finished pieces.

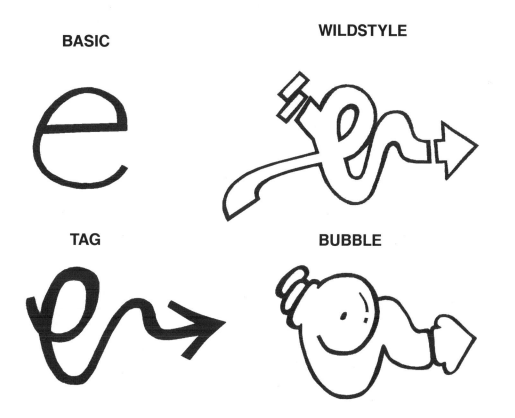

BASIC

WILDSTYLE

TAG

BUBBLE

SECTION THREE

LAYOUT
AND
PIECING

INTRODUCTION TO LAYOUT AND PIECING

This section on layout and piecing will explain how a graffiti word design or piece should be organized and arranged on a paper. Layout refers to how a design should be planned and is a blueprint for where things go. Piecing comes from the word piece, short for masterpiece, and it means molding the letters together to form a word. In a piece letters are seperate elements that connect and combine in a variety of ways to form one shape with symmetry throughout the whole. It's like a jigsaw puzzle where all the pieces fit together perfectly.

There aren't any set rules for piecing, but there are some established methods and techniques. The graffiti term we like to use for how letters and other elements work together is called the flow of the piece. The details and shapes of the letters and how they flow is called the style of the piece.

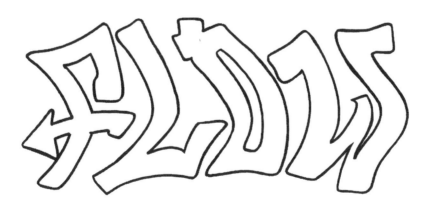

In the word "FLOW" above, the verticle bars of the letters are all bent sharply in the middle toward the right to create flow throughout the whole word.

GRAFFITI ART IS ALL ABOUT STYLE

There are many different definitions to describe exactly what constitutes style. We will define it as letters that are drawn with funk and attitude, fit together nicely with a feeling of movement and energy, and are imaginative and well drawn.

To "have style" means to draw in a way that is uniquely you. Something recognizable that makes your artwork stand out from everyone else's. Style is what a graffiti artist strives for. Style is a quality that you can develop over time with lots of practice and huge amounts of patience. In this section, we will demonstrate layout and piecing techniques that you can use to develop your own graffiti designs and eventually your own style.

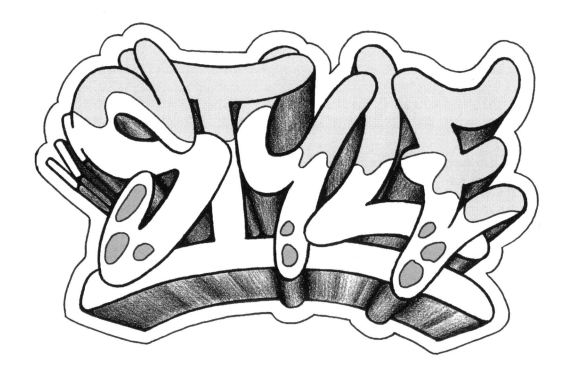

This chapter is the core of this book, because it shows you how to construct a wildstyle word. Just like with bubble, block and tag letter words, wildstyle words start out with simple outline letters spaced evenly apart. This refers to the *layout* of the word. Once this foundation is established, the letters are then modfied by molding, bending and extending them in and around each other to form an interesting, dynamic, flowing pattern. This refers to the *peicing* of the word.

EXAMPLE #1

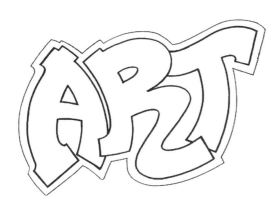

In this exercise, the word "ART" on the left is our finished wild-style word and the word "ART" in the box below is our starting point drawing. The layout starts with simple outline letters that are then pieced to form the finished design. Follow the steps.

STEP 1. To begin, draw guidelines above and below to help line up the letters. Then draw the word "ART" lightly with a pencil. Spread the letters out so you have room to build them up.

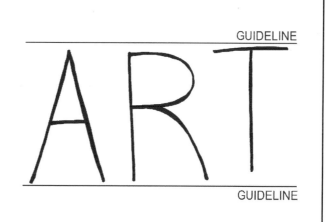

GUIDELINE

GUIDELINE

STEP 2. Draw bars around each letter to turn the letters into outline letters.

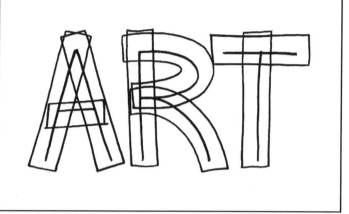

STEP 3. Erase all the inside guidelines.

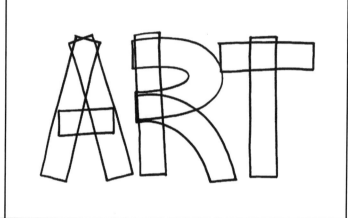

STEP 4. Now bend the bars of each letter, molding and twisting the bars in and around each other so that the letters flow together in a nice pattern.

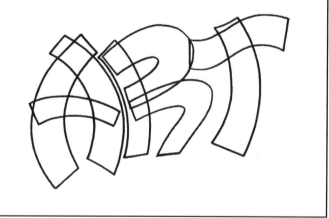

Notice how the bars of all three letters are bent towards the left.
This creates flow.

STEP 5. Draw a small bar on the bottom of the "A" to create a serif. Do the same thing on the bottom of the "R" and on the top of the "T". Extend the bottom of the "R" in a swooping line.

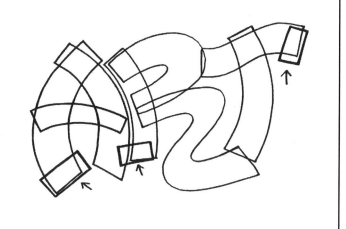

STEP 6. Draw dark lines all around the outside edges of the letters and erase the inside guidelines. Draw the letters overlapping just a bit

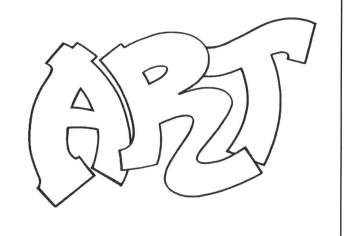

STEP 7. Draw a force-field surrounding the whole word.

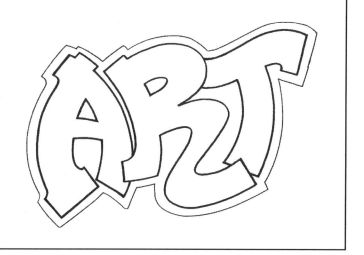

EXAMPLE #2 - This is a drawing from one of our students.

STEP 1. Draw the letters of your word. Space them far apart so you have room to build them up.

GUIDELINE

GUIDELINE

STEP 2. Draw bars around the strokes of the letters to form outline letters.

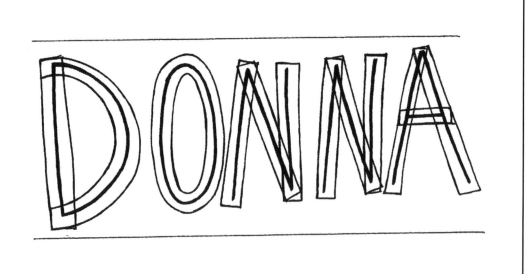

© GRAFFITI DIPLOMACY

STEP 3. Draw a dark line around the outside edges and erase all of the guidelines.

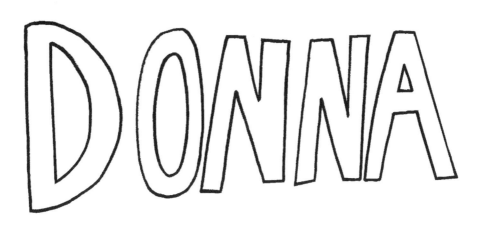

STEP 4. Modify your letters by bending the bars and adding extensions and an arrow. Be creative.

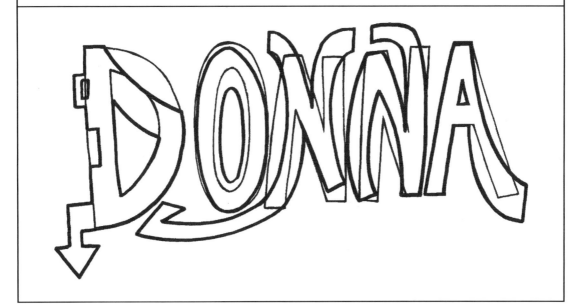

STEP 5. Redraw the letters, erasing all of the unnecessary guidelines. Add lots of bits.

Notice how different the two "N's" are, yet they work together really well.

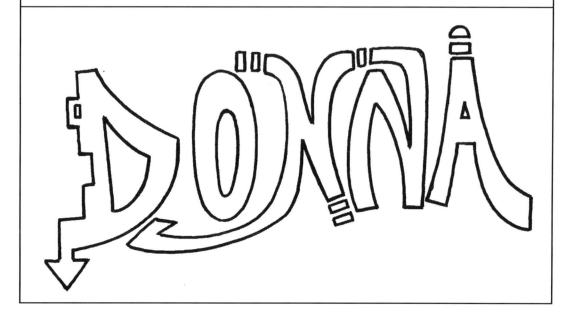

STEP 6. Bunch the letters close together and overlap the edges of the letters "D" and "O". Connect the "D" and the "N" (we will cover connections in detail later on). Add a force-field if you like to define the shape of the whole name.

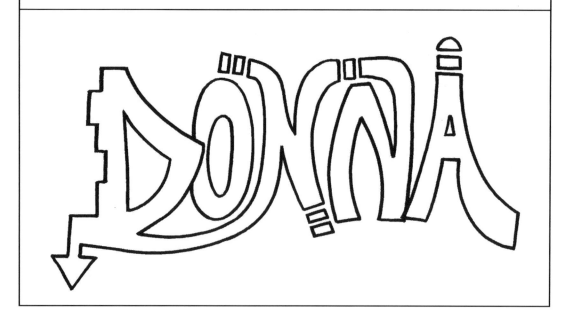

CHAPTER TWENTY-ONE
PRINCIPALS OF DESIGN

The principals of design that are used to compose a fine art portrait or landscape picture are also used in graffiti art to construct a great graffiti piece. These principals can help guide you in the arrangement of the various elements of a design on your page. Here is just a short overview of these principals along with some suggestions for how to use them in your pieces.

Balance in a design means the different parts of a picture are equal in weight. Create **balance** by adding bits on one side of a letter and an arrow on the other side.

Rhythm and Movement are the repetition of elements throughout a design. For example, a pattern has **rhythm and movement**. Or you can bend bars in the same direction to create **rhythm and movement**.

Unity means to pull together all of the elements of your design so it looks complete. Make all of your letters in a similar style (ie: all sans-serif bubble letters) to create **unity**.

Contrast refers to having different or opposite elements inside the same design to give it interest. Make some letters bigger and some smaller, or make some uppercase and some lowercase to create **contrast**.

Emphasis means making one element in a design more important so that it grabs your attention. Add some kind of element that stands out or make one letter totally different from the rest to create **emphasis**.

Proportion refers to the size of one element in a design as compared to another, and how the parts fit together to make a whole. Draw guidelines above and below the piece to keep your letters in **proportion**.

Positive and Negative Space are the subject (**positive space**) in a picture and the background (**negative space**) that surrounds it. Both are equally important and are needed to create a complete picture. Pay equal attention to your letters (positive space) and the background (negative space) that surrounds them.

This finished graffiti piece successfully incorporates some of the principals of design:

1) The flame pattern in the letters creates **rhythm and movement**.

2) The letters are drawn in a similar style to create **unity**.

3) The two "N's" are drawn differently from each other to create **contrast**.

4) The intricate cuts on the left side of the "D" create **emphasis**. Can you find any others?

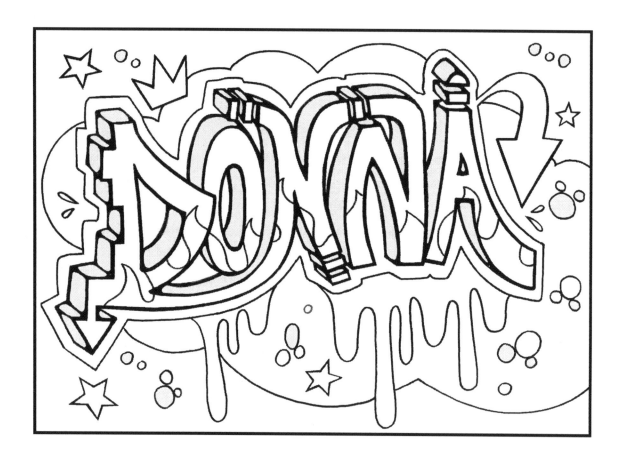

Think about these principals when drawing your letters. Using them will make designing your pieces easier.

One really unique characteristic of the graffiti art form is that it is kind of a secret. There are no classes we can recommend you take that we are aware of and very few instructional books that teach the ins and outs. So learning how to draw graffiti can be challenging. One remarkable aspect of graffiti lettering that we have discovered is this: even the most complex wildstyle pieces start out as simple line drawings. Another important discovery we have made is that the more complicated a piece is, the more fascinating it is. That means adding lots of arrows, extensions, and bits. Connections, which we will cover in the next chapter, are the cherry on top of the cake. In this chapter we will demonstrate how to use advanced layout and piecing techniques to modify the following tag words "POW", "ZAP", and "STYLE" into wildstyle words. Starting with tag letters gives you a headstart on adding movement to your composition. This chapter will teach you methods you can use to help you push your graffiti skills to the next level. Study the step-by-step instructions on the following pages and then try this method with your own name or word.

In "ZAP" the bottom stroke of the letter "Z" is used as a platform extending underneath and underlining the other letters in the word.

Start out by drawing the letters lightly with a pencil so you can erase them later on. We have drawn them darkly so you can see them clearly. Experiment with different layouts, arranging the letters in various ways until you find a layout that you like.

To add new drawings, either place a clean piece of paper on top to trace your drawings and create new ones as you go, or just use your eraser and draw light pencil lines. You need to experiment and choose a technique that you feel comfortable with. You will be redrawing the word several times, so get lots of paper and give yourself plenty of time. You don't have to finish this all in one session. After you go through the exercise with our example go through the same steps with your own word.

EXAMPLE #1

| STEP 1. Decide on the letters that you want to have in your piece. Make guidelines above and below to help you keep the letters lined up and in proportion. Then start out by drawing simple tag letters with pencil lines. | 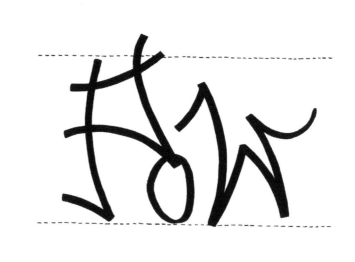 |

NOTE: Drawing guidelines above and below your word is optional, but it will provide a framework to help you line up your letters and design a balanced, well proportioned piece.

STEP 2. Lightly sketch in bars surrounding the strokes of each letter to form the basic shapes. Try to visualize your design and fatten up the letters to make them into outline letters.

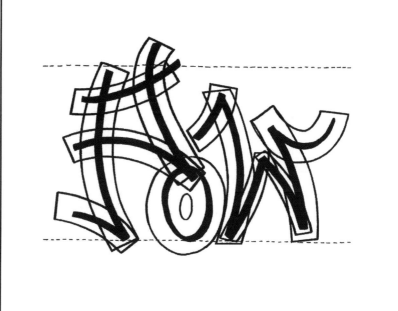

STEP 3. At this stage you can erase the original letter if you want.

Look at the parts of the letters that overlap. Decide which letters will be in front and which will be behind. Erase all of the extra, unneccessary lines.

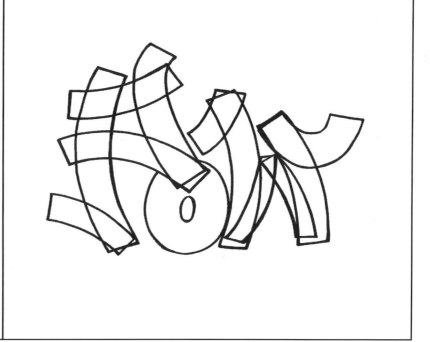

STEP 4. Draw all around the outside edges of your letters with a dark line and erase the inside guidelines. You can trace your new, revised sketch onto a clean sheet of paper if you like. You should have a clean drawing with well defined outline letters at this stage.

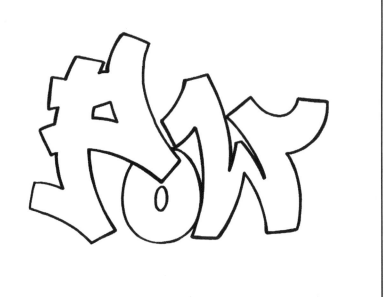

STEP 5. Begin to mold the letters into each other making them fatter and rounder with smooth edges. Define the outlines of the letters. Draw a dark line all around the outside edges of your letters.

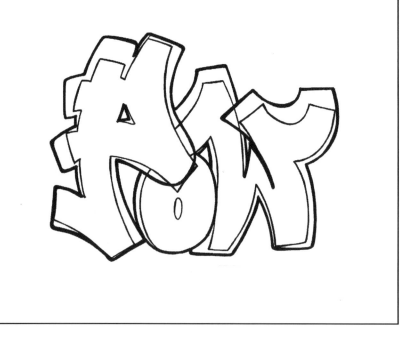

*Fatten and round out your letters. Mold and sculpt them into each other.

STEP 6. Once again, erase any of the inside lines that you no longer need.

If you prefer you can place a clean sheet of paper on top and trace a new, clean drawing.

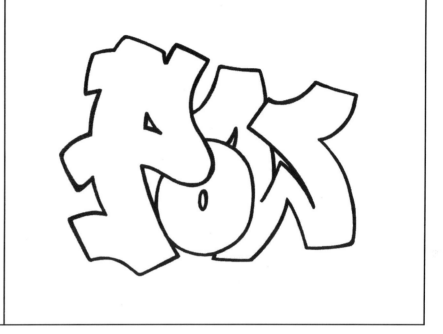

STEP 7. Now you can experiment with adding extensions and arrows to your word design. Sketch out the shapes. Think about the movement of the whole word together. Blend in the new lines to the original lines of the letters. Sketch in bits.

STEP 8. This is the last step.

When you think the piece looks finished you can begin to define and darken the lines you want to keep. Erase any of the lines you don't need. Add any additional details. Draw a dark, clean line all around the outside edges of the letters.

At this point you can redraw or trace your design onto a clean sheet of paper if you like. Make your drawing sharp and crisp. This is your finished drawing.

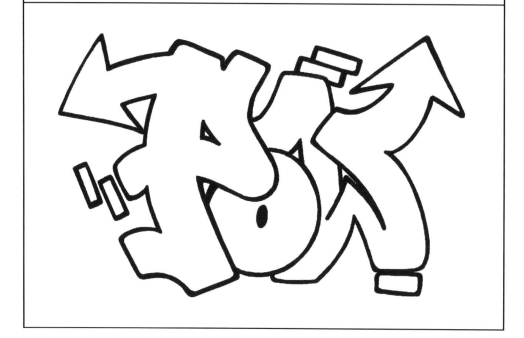

One approach to piecing is to try to visualize the finished word you are going to create. To visualize it means to picture the finished word in your mind the way you would like it to look. Personally we prefer to just draw and draw without any clear destination and see where the drawing takes us. Both approaches are totally valid and you can try them both.

EXAMPLE #2

To lay out and piece the word "Zap" stretch out the bottom stroke of the "Z" to form a platform underneath the other letters in the word.

STEP 1. Start out by drawing the letters in simple lines with a pencil. Draw lightly. Make guidelines above and below the piece to help you keep the letters lined up and in proportion.

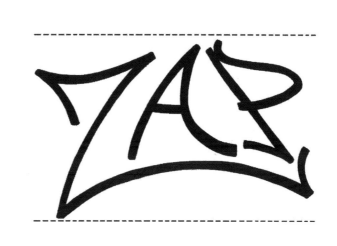

STEP 2. Lightly sketch in bars surrounding the strokes of each letter to form the basic shapes. Try to visualize your design and use the bars to fatten up the letters into outline letters. Think about what kind of movement you want your letters to have. Don't worry if it looks messy and confusing at this stage.

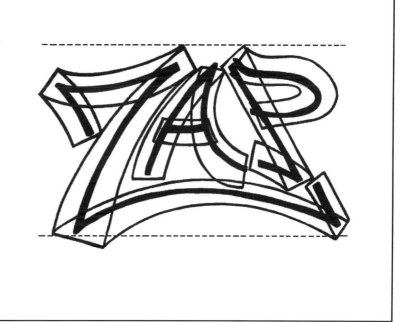

STEP 3. At this stage you can erase the original letter if you want to make your drawing less crowded and busy.

Where you have overlapping edges, decide which letters will be in front and which letters will be behind. Erase any overlapping, unneeded lines.

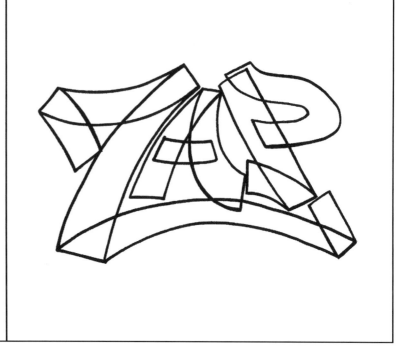

STEP 4. Draw all around the outside edges of your letters and erase the inside guidelines.

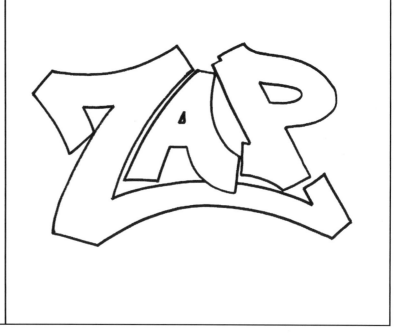

STEP 5. Think about the shapes of the letters you want to draw. Mold the letters into each other making them fatter and rounder with smooth edges. Extend the ends of the serifs.

This step is where you try to add funk and personality to your letters. Define the outlines of the letters. Draw a new dark line all around the outside edges.

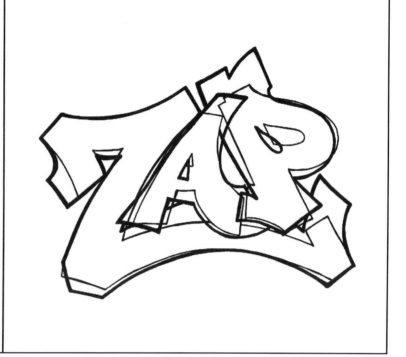

STEP 6. Once again, erase any of the lines that you no longer need.

If you prefer you can place a clean sheet of paper on top and trace a new, clean drawing with the new outlines.

Almost done…

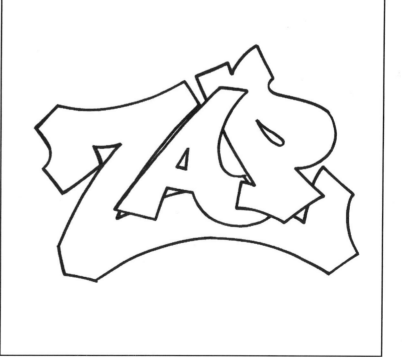

STEP 7. Now you can experiment with adding extensions and arrows to your word design. Sketch out the shapes. Think about the movement and design of the whole word together. Blend in the new lines to the original lines of the letters. Add bits.

STEP 8. This is the last step. When you think the piece looks finished you can begin to define and darken the lines you want to keep. Erase any of the lines you don't need. Add any additional details like a starburst between the "A" and the "P" to fill up the space. Add action lines. Draw a dark, clean line all around the outside edges of the letters.

At this point you can redraw or trace your design onto a clean sheet of paper. Make your drawing sharp and crisp.

The great benefit of laying out a word with tag letters is that the bars of the letters are already bent. The letters have movement and style, because tag lettering is a stylish form of lettering. In this next example we use ovals or soft bars to form the outline letters from tag letters. Then we piece and complete the word

EXAMPLE #3

STEP 1. Make guidelines above and below the piece to help you keep the letters lined up and in proportion. Start out by drawing the tag letters in simple lines with a pencil. Draw lightly.	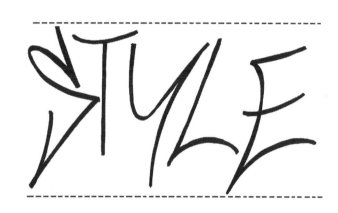

STEP 2. Lightly sketch in ovals or soft bars surrounding the strokes of each letter to form the basic shapes. Try to visualize your design and use the bars to fatten up the letters into outline letters.

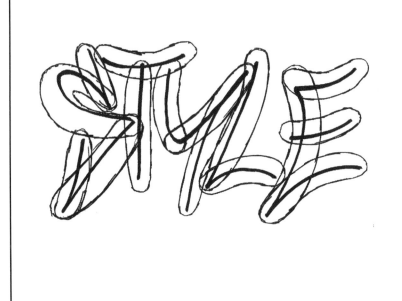

STEP 3. At this stage you can erase the original letter if you want to make your drawing less crowded and busy.

Don't worry if it looks a little bit like messy spaghetti. We will clean it up in a second.

STEP 4. Draw all around the outside edges of your letters and erase the inside guidelines. Where you have overlapping edges, decide which letters will be in front and which letters will be behind. Mold the letters into each other, making them fatter and rounder with smooth edges. Erase any overlapping, unneeded lines.

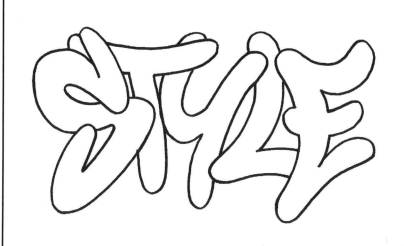

STEP 5. Sketch in a bar for a platform underneath the letters and a small bar for an extension on the left side of the "S".

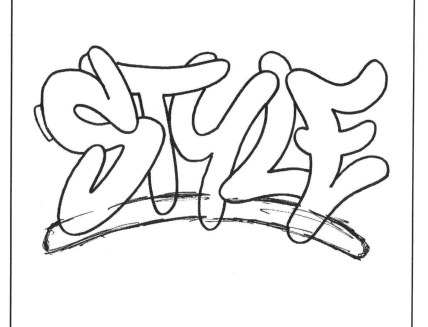

STEP 6. Clean up and define the edges of the letters. Add two small bits on the left side of the "S". Redraw or trace your finished drawing onto a clean of paper. Make it sharp and crisp.

From here you can add any other details that you want.

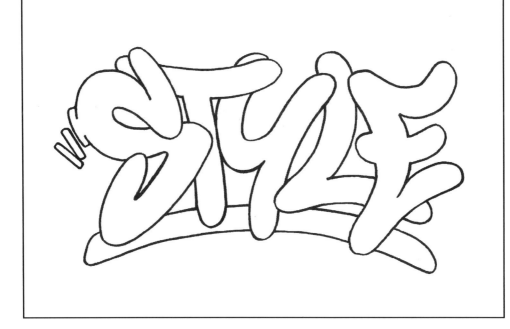

In summary, you can lay out and piece any word that you want by starting with tag letters and a simple line drawing. Space the letters apart and build them into outline letters using any of the techniques we covered in Section One. Bend the letters and modify them. Fatten them up and mold them into each other to create a flowing feeling and an interesting arrangement. It may take some time and seem complicated at first, but both style and flow will come to you with practice. By now you are probably tired of us telling you to "practice'" but it really is the only way to master this art form.

CHAPTER TWENTY-THREE
CONNECTIONS BETWEEN LETTERS

Connections are created to attach individual letters in a word. They come from the natural flow of scripted handwriting, like in the example of the letters "AR" below on the left. As with all things graffiti, connections originated with tag lettering. Connections appeared early on in graffiti history and evolved along with the art form itself to become a standard component of wildstyle letter design. Connections increase the sensation of flow and movement in a piece as your eye naturally glides along the path from one attached shape to the next. Our favorite kind of connection is when two letters share one line. In the example on the right, the bottom stroke of the "C" extends out to form the crossbar of the "A", thereby connecting the two letters.

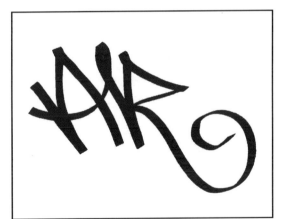 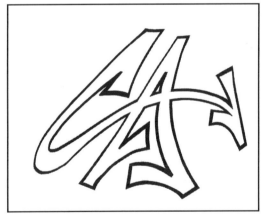

You can make connections as simple or as complicated as you want. You can attach letters at any points. You can extend and connect serifs. Or you can add extensions onto the letters and then connect the extensions.

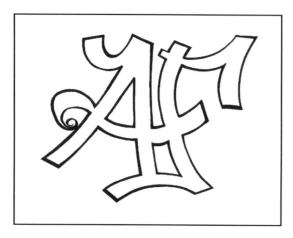

There are two connections between this "A" and "F".

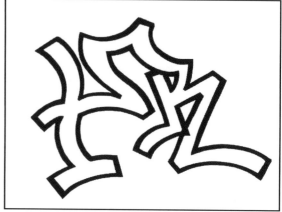

There is one connection between this "P" and "R".

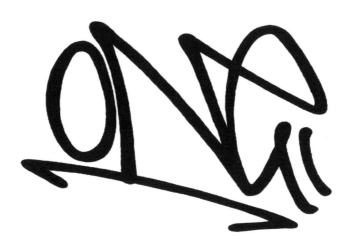

Connections are the pinnacle of graffiti lettering. They are where an individual's personal style and imagination are showcased. Connections are complex so they require thought, creativity, and lots of sketching and experimentation to create.

Connections can start out very simply. This tag word "ONE" has three connection points and it illustrates that connections between letters can originate at the very beginning when a tag is first drawn, as a part of the initial tag. But connections can also be added later on after you build up your outline letters. The next two exercises illustrate this concept.

EXAMPLE # 1

In this exercise we start with a much more dynamic layout by rotating the letters sharply at different angles. Once we have formed the letters into outline letters, we will look for places to add connection points between the letters.

STEP 1. Decide on the style of letters and other elements that you want to have in your piece. Then draw the letters with simple pencil lines. Make guidelines above and below the piece to help you keep the letters lined up and in proportion.

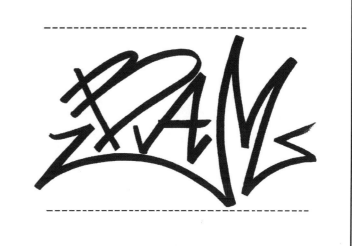

In this composition we have strived to get lots of movement in the layout by rotating the letters and using lots of serifs.

STEP 2. Think about what kind of look and style you want your letters to have. Lightly sketch in bars surrounding the strokes of each letter to form the basic shapes. Try to visualize your design and fatten up the letters.

Erase as needed to help keep track of which lines are part of which letters.

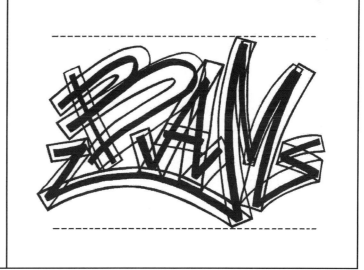

It looks like a tangled mess of lines at this step, but try to keep track of which lines go to which letter. We'll clean it up in a minute. If you find it too confusing try drawing each letter in a different color.

STEP 3. At this stage you can erase the original letter if you want. This will make the letters easier to see and work with.

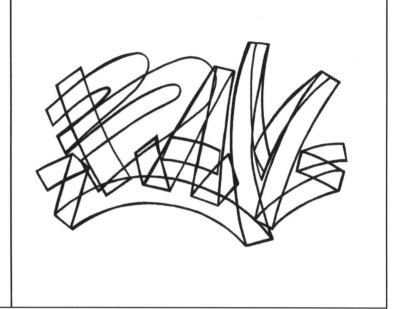

STEP 4. Draw all around the outside edges of your letters with a dark line and erase the inside guidelines.

You can trace your new, revised sketch onto a clean sheet of paper if you like. Or just erase the unneeded lines really well.

At this stage there are still extra overlapping lines.

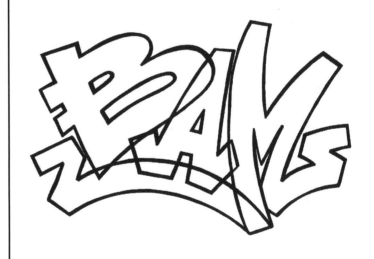

STEP 5. Look at the parts of the letters that overlap. Decide which letters will be in front and which will be behind. Erase any extra, unneeded lines.

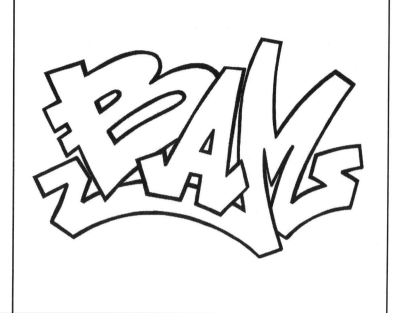

STEP 6. This is the important step. Look for places in your design where letters can connect to one another. Add lines where needed to form the connections. Erase any unneeded lines at these connection points.

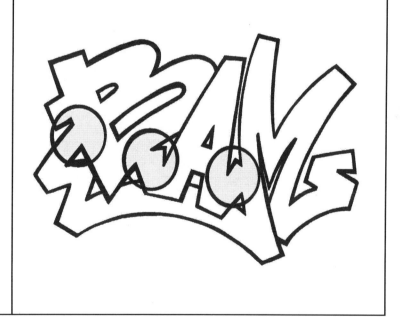

There are no exact rules to doing this and you have to experiment with different options until you get to a point where you are happy with your drawing. We have circled and shaded in the three connection points with light grey that we chose for this piece so you can see them clearly.

STEP 7. Redraw your letters with the connections in place. Experiment with adding extensions and arrows to your design. Sketch them in where you think they will look good. Add bits. Blend in the new lines to the letters.

STEP 8. When you think the piece looks finished you can define and darken the lines you want to keep. Draw all around the outside edges with a thick dark line and erase any of the lines that you don't need. Add any additional details you think will look interesting. We added a little kung-fu guy standing on the extension of the "M".

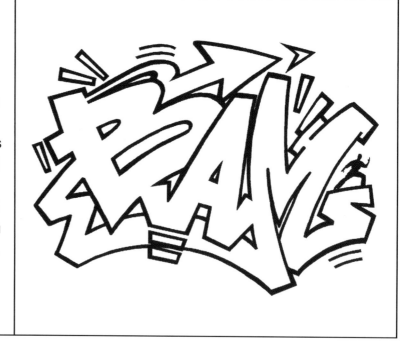

At this point you can redraw or trace your design onto a clean sheet of paper if you like. Make your drawing sharp and crisp. Neatness counts.

EXAMPLE 2

STEP 1.

Draw tag letters with simple pencil lines. Make guidelines above and below the piece to help you keep the letters lined up and in proportion.

STEP 2.

Lightly sketch in bars surrounding the strokes of each letter to form the basic shapes. Try to visualize your design and fatten up the letters.

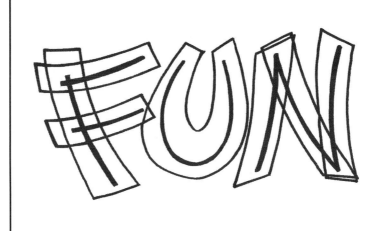

STEP 3.

Draw all around the outside edges and erase the original letter. This will make the letters easier to see and work with.

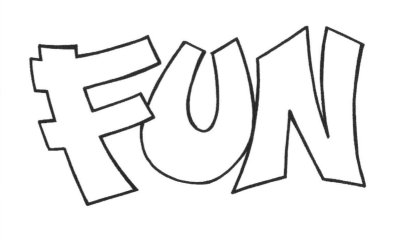

STEP 4.

Add small bars for serifs on all three letters. At this stage there are extra, overlapping lines.

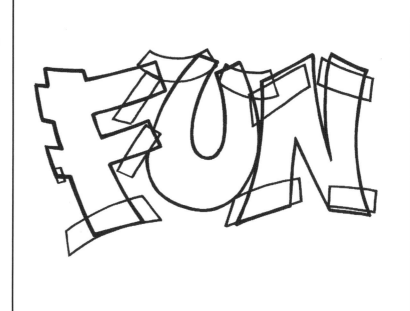

STEP 5.

Look at the parts of the letters that overlap. Decide which letters will be in front and which will be behind. Erase any extra unneeded lines. Redraw your word on a clean sheet of paper.

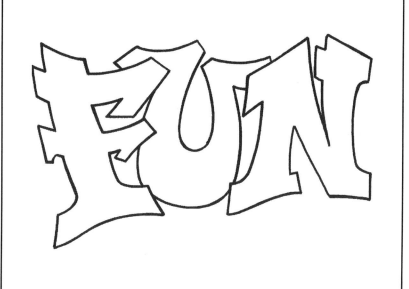

STEP 6.

Sketch in a line extending from the serif on the left side of the "F" to the serif on the bottom of the "N". Curve the line and wrap it around the "U" kind of like a vine. This curved line forms a connection between the letter "F" and letter "N". Next, add an arrow on top of the letter "U". Draw 2 small bits on the left side and 2 bits on the right side.

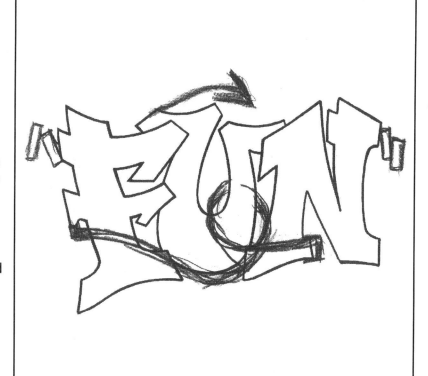

STEP 7.

Now redraw or trace your finished design onto a clean sheet of paper. Blend all the lines together. Make your drawing sharp and crisp. Add any additional details you think will look interesting. We added a few leaves on the vine to fill up the space and some drippy goop and dots on the letters for decorations.

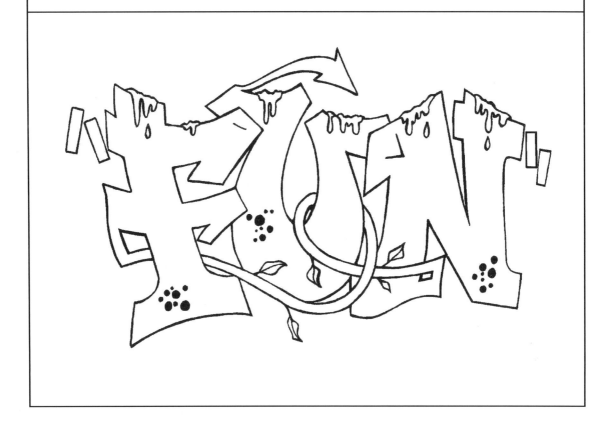

The only thing missing from these letters is 3-D. We will come back to and finish this drawing later on in Section Four.

CHAPTER TWENTY-FOUR
DESIGNING A LAYOUT WITH CUTOUTS

Sometimes it's too time consuming to design a piece using the layout and piecing techniques we just learned. That's when this alternative method comes in handy. First draw your word in any style of letters. In the example below, we are using tag letters again. Then form your letters into chunky outline letters using one of the techniques from Section One. Next, cut each letter out with a scissors. Then place the cutouts on a piece of paper and move them around in different positions. Try several compositions until you find one that you like. Then place a piece of paper on top and trace the letters in the final arrangement. Now you have your finished layout. This technique works like a charm and saves you time and energy.

STEP 1. Draw the letters of the word with pencil lines.

STEP 2. Spread the letters far apart and draw a dark line around the outside edges of the letters.

STEP 3. Erase the inside lines. Then cut each letter out around the outline.

STEP 1.

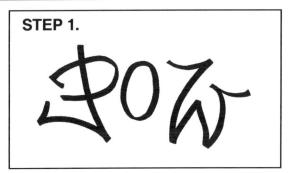

STEP 2.

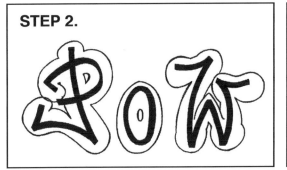

STEP 3. **CUTOUTS**

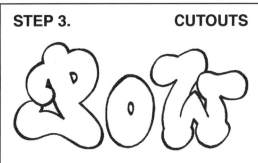

Move the cutout letters around in a few different arrangements. When you find one that you like, tape the letters down and then trace the finished design on a clean sheet of paper. This works really well with any style of letters. You can use your finished drawing as a base on which to add extensions, arrows, connections or bits. Add a force-field around your finished design. Save the cutouts to reuse again and again.

VARIATION #1

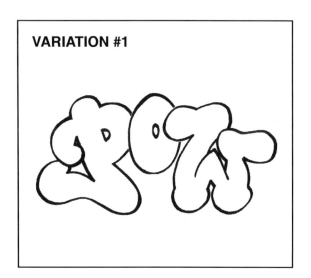

VARIATION #2

VARIATION #3

VARIATION #4 WITH A FORCE-FIELD

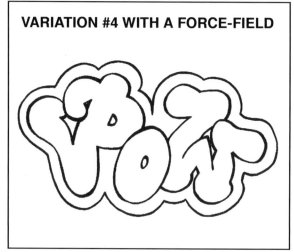

MODIFYING MOVEMENT WITH GUIDELINES

It is essential that all of the different elements in a word fit together in some kind of unified pattern that is pleasing to the eye. Modifying the movement of your piece by using guidelines that are laid out in different directions is a simple technique that allows you to arrange your letters evenly while creating new and unique letter compositions. To do this, start out by drawing two guidelines to indicate the direction that you want your letters to go in and the overall shape you want your finished design to have. Then mold your letters to fit in between the guidelines, following the shape and curve of the lines.

Designing words in this way gives them a flowing feeling, like a flag blowing in the wind, with all the letters moving together simultaneously and in harmony. You can use any style of letters with this technique.

Try this exercise: Copy the curved guidelines above onto a piece of paper and then draw your own word or name in between the dotted lines. Stretch and bend the letters so that they are touching the lines on top and on the bottom.

Draw the guidelines in any direction and squeeze the letters to fit in between the lines.

Make the guidelines as curvy and distorted as you want. Stretch the letters to fit in between.

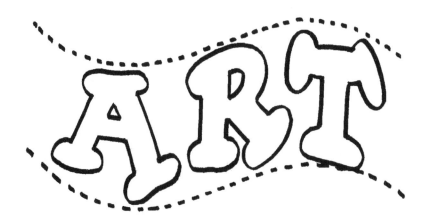

162

MODIFYING LETTERS INDIVIDUALLY

Individual letters in a word can be manipulated independently and then assembled together like puzzle pieces. In this technique each letter is separate and unique. Modifying letters in a word individually gives you more layout options. Letters can be substituted with objects that have similar shapes, like substituting a letter "T" with two crossed paintbrushes or substituting a letter "o" with something round, like an eyeball. Or letters can flip and rotate in the middle of a word. Careful consideration should be given to how letters fit together to form a well-structured word. Embellishments like arrows or extensions can be added later, after you have built a solid foundation. Think about how the whole shape of the word will look when it's complete. Add a force-field to clarify and define the overall shape. Create a finished shape this is energetic and exciting.

Stretch and distort the letters to fit around each other. Here's your chance to use your creativity to really extend and modify the bars of the letters as much as possible. Add a force-field when you're done to help define the overall shape.

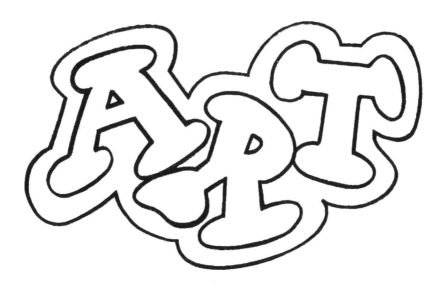

Turn a letter upside down or backwards. Draw a mirror image of the word or turn the whole word backwards. Push the boundaries of how a traditional word should be drawn.

Try combining both techniques. Draw curved guidelines and then modify each letter individually. Make each letter seperate and unique, but keep the overall style of the letters the same. This will help you create a really dynamic composition.

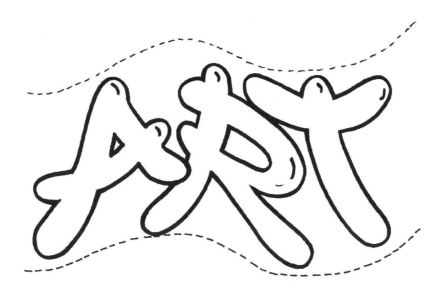

Play around with the letters and see what interesting relationships you can draw between them. Try overlapping the corners. This "R" looks like it's stepping on the foot of the "T".

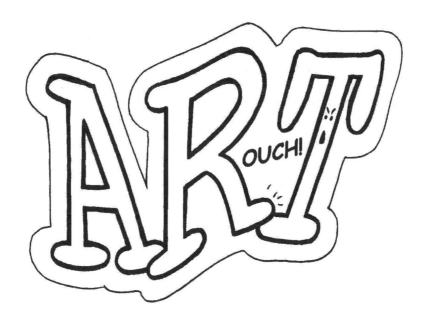

SECTION FOUR

THREE DIMENSIONAL LETTERS

CHAPTER TWENTY-SEVEN
3-D DRAWING WITH A VANISHING POINT

Perspective drawing or three dimensional drawing (3-D) is the art of drawing objects on a flat surface in such a way that they appear to have depth. A flat surface, such as this piece of paper, is considered "two dimensional". An object that has depth, like this thick book, is considered "three dimensional". Depth also refers to how close up or far away an object appears in a picture. Perspective drawing is an optical illusion, because objects that are closer appear to be larger and more detailed, while objects that are further away appear to be smaller and less detailed. They may not be that way in real life. An optical illusion tricks your eye into seeing something different then actually exists.

VANISHING POINT

3-D lettering was introduced into graffiti art in the early 1970's and was quickly adopted by many writers as a standard way to draw graffiti letters. Letters drawn in a 3-D style are dramatic and bold, and appear to jump off the surface on which they are drawn, especially if they have strong colors. You can make your 3-D letters look fat or skinny, tilt them forwards or backwards, or overlap them so that one letter looks like it is in front of another. With experience, you will be able to add 3-D to your graffiti letters freehand, but first you need to learn some basic rules and structured techniques. Then you can begin editing or revising the techniques in your own way.

Perspective drawing is both an art and a science. Italian Renaissance Painter Leonardo Da Vinci (1452-1519) conducted many scientific studies for his drawings and paintings so he could understand how to use perspective drawing in his art works. He discovered that there are two kinds of perspective, which he called Linear perspective and Aerial perspective. Linear perspective refers to the way objects look smaller as they move further away into the distance. Aerial perspective refers to the way objects get lighter in color and seem to have less detail as they move further away. In this example below of both linear and aerial perspective drawing, notice how all of the objects get smaller as they get further away. The tracks, the bushes, the horses, the train signals, the fence, and the side of the building all appear to get smaller. The rails on the track seem to get closer together until they meet at a tiny point high up in the picture frame. The mountains look small compared to objects that are closer up. The details on the objects start to fade into the distance. Eventually all of the objects get so far away that they become tiny little dots in the distance and then they disappear. Those tiny dots in the distance where objects disappear are called vanishing points.

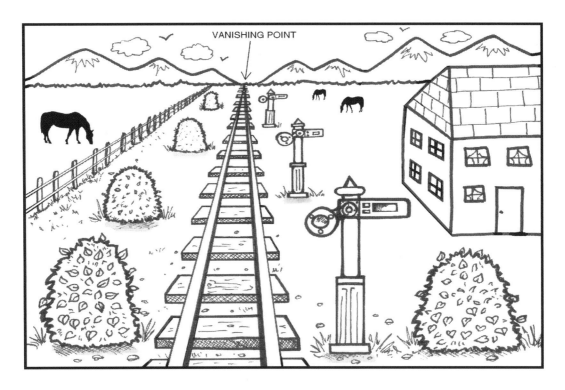

When an object gets further away from your eye it gets smaller and smaller until it becomes a tiny dot in the distance and eventually it disappears from view. That spot in the distance where the object disappears is called a vanishing point.

Using Vanishing Points to Draw Graffiti Letters

Vanishing points are used in graffiti art to draw letters that are three dimensional. A vanishing point is used as a guide to show you exactly where to draw the sides, top or bottom of a letter. You can place a vanishing point anywhere on your paper. We'll start off with a basic block letter "L". Once you understand the basic concept, we will move on to more complex letters.

STEP 1.
Draw a block letter "L". Draw a dot or vanishing point a short distance from the letter "L".

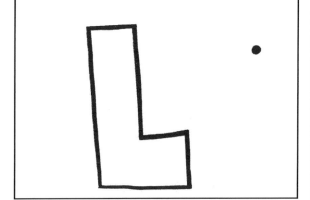

STEP 2.
Lightly draw guidelines from the corners of the letter "L" to the vanishing point. You can use a ruler to help you draw the lines.

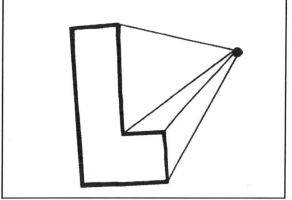

STEP 3.
To form the sides, draw parallel lines that follow the shape of the "L". Stay inside the guidelines.

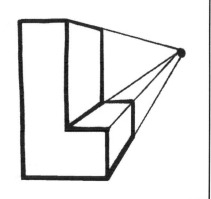

STEP 4.
Erase the vanishing point and the guidelines. Add a darker color to the sides of the letter "L" to make it look more three dimensional.

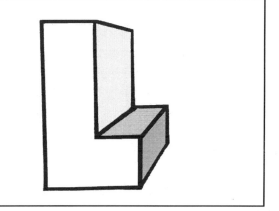

No matter where you put the vanishing point on your paper the process to create the sides, top or bottom of a letter is the same. Lightly draw guidelines from the corners of the letter to the vanishing point. Then draw lines following the shape of the letter to form the sides, top or bottom. You can make the letters as thick or as thin as you like. Just remember to stay inside the guidelines. Letters with curves, like "B, C, P, or U" are created in the same way. Mold the sides to follow the shape of the letter, as in these examples.

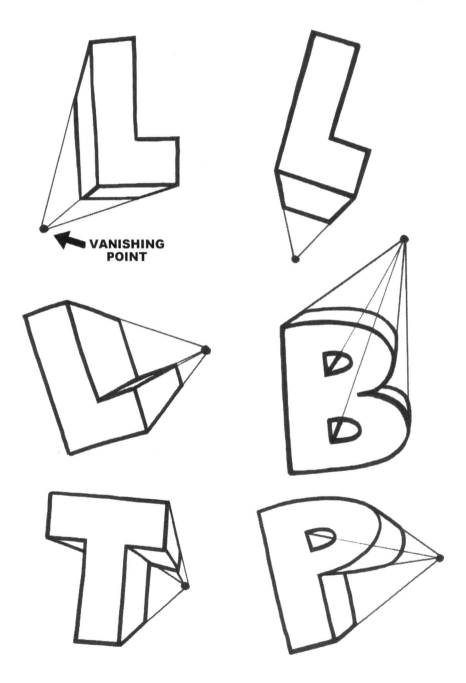

VANISHING POINT

Draw a vanishing point in the middle of the page and place bubble letters around it in a circle. Draw lines from the vanishing point to all the corners of all the letters. Then draw lines following the shape of the letters to form the sides, tops and bottoms. Add a little shading in the 3-D around the edges.

You can place a vanishing point anywhwere that you want and place your letters a short distance away.

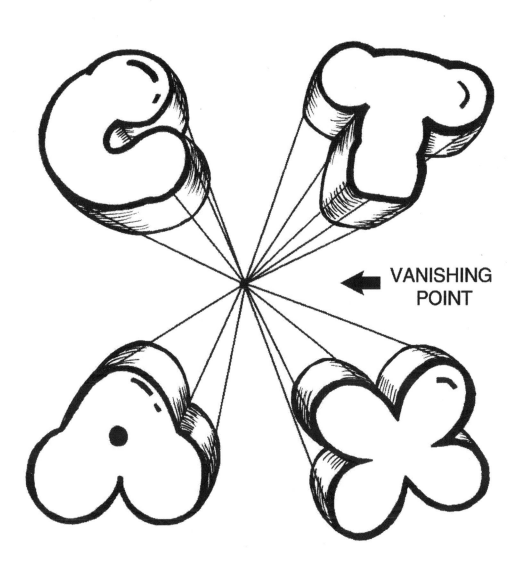

VANISHING POINT

EXAMPLE #1 - A WILDSTYLE LETTER "M"

Here is an example of a wildstyle letter with 3-D added. The process is the same as with block letters and bubble letters. Don't worry if it looks kind of complicated at first. This is a technique that takes some study and practice to master. Follow the steps.

STEP 1.
Draw a wildstyle letter with extensions, arrows and bits. Place a vanishing point several inches below the bottom of the letter.

VANISHING POINT

STEP 2.
Next, draw lines connecting all of the corners of the letter to the vanishing point, including the arrow, extensions, and bits.

Using a ruler to draw the lines will help a lot.

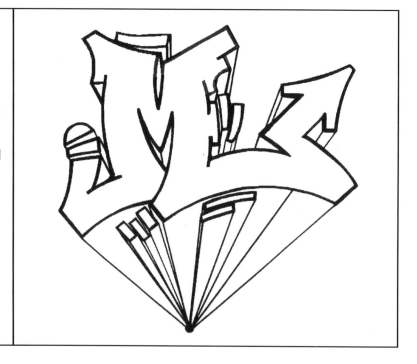

STEP 3.

Then draw parallel lines following the shape of the letter to form the sides, top and bottom sections. Make all of the sections the same thickness.

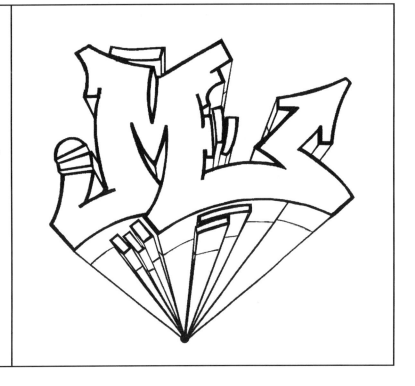

STEP 4.

Erase the guidelines. Then shade in the 3-D sections. We used a black colored pencil for this step.

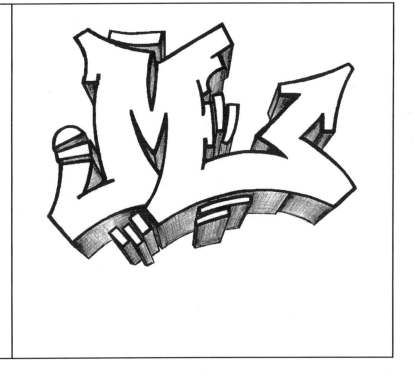

If it seems really complicated to you, don't worry. It is complicated. In the next chapter we will show you a 3-D shortcut method that you will definitely find a lot easier to work with in the beginning.

EXAMPLE #2 - A WHOLE WORD

STEP 1.

Draw a wildstyle word with extensions, arrows and bits. Place a vanishing point several inches below the bottom of the word.

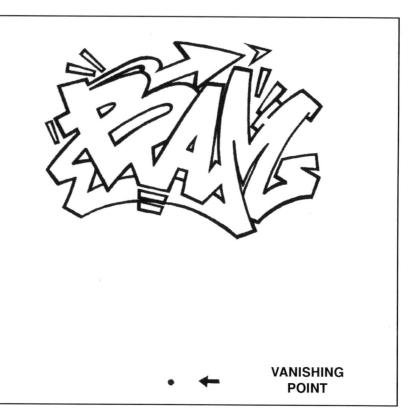

VANISHING POINT

STEP 2.

Next, draw lines connecting all of the corners of the letters to the vanishing point, including the arrow, extensions, and bits. Use a ruler if needed.

STEP 3.

Then draw parallel lines following the shape of the letter to form the sides and bottom sections. Make all of the sections the same thickness.

STEP 4.

Erase the guidelines and the vanishing point. Then darken in the 3-D sections.

Place a vanishing point anywhere on your paper and draw lines connecting the corners of the letters to the vanishing point. Then form the sides, tops or bottoms.

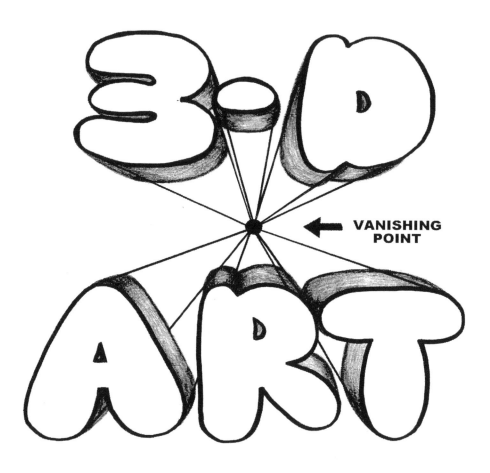

Adding 3-D to your letters will really spice up your graffiti drawings. Once you train your eye to see letters in this way, the simplest bubble letters and the most complicated wildstyle letters will not look complete without 3-D added.

3-D SHORTCUT METHOD

Perspective drawing with a vanishing point is very complex and some people might find it difficult to work with. But there is an easier way to add 3-D to your letters that doesn't require vanishing points or rulers. Although this shortcut method doesn't follow the scientific rules of perspective invented by Leonardo Da Vinci, it works really well as a quick way to draw great looking 3-D letters without a lot of preparation and planning. We use this shortcut method all the time. Whether you are a skilled graffiti artist or a beginner who is just starting out, you will find this shortcut method useful. On the following pages, we'll demonstrate how it works. Then on the last page of this chapter we'll show you one final quicker, even easier method. You can mix and match any or all of these 3 dimensional techniques to make your letters look lively and interesting.

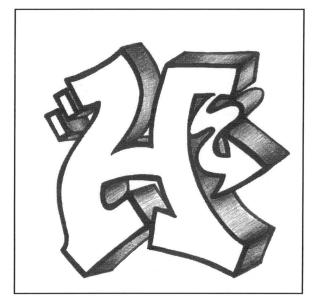

3-D is added to this wildstyle letter using the shortcut method. It looks just as good as the traditional 3-D method from Chapter 27. Turn the page to see how it's done.

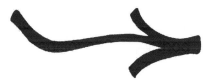

SHORT-CUT METHOD TO DRAW 3-D LETTERS

STEP 1. First draw a square on a piece of paper. Then place a clean sheet of paper on top and trace the square.

STEP 2. Next, move the top paper a little bit in any direction and trace the square a second time, overlapping the first square.

STEP 3. Erase the lines that are overlapping. Your squares will look like this, with one square in front of the other.

STEP 4. Draw lines to connect the corners of the two squares.

STEP 5. Erase the inside lines. Your square is now a three dimensional cube.

NOW TRY THE SHORT-CUT METHOD WITH A BLOCK LETTER

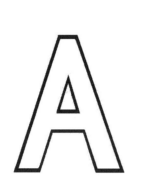

STEP 1. Draw a block letter "A" on a sheet of paper. Place a clean sheet of paper on top and trace the "A".

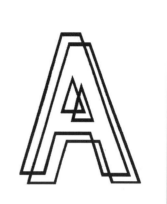

STEP 2. Move the top paper a little bit in any direction and trace the letter "A" a second time, overlapping the first "A".

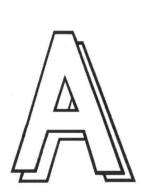

STEP 3. Erase the lines that are overlapping. Your letters will look like this, with one "A" in front of the other.

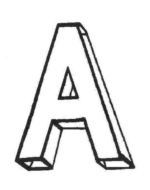

STEP 4. Draw lines to connect the corners of the two letters.

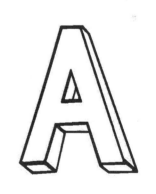

STEP 5. Erase any unneeded lines. Your "A" is now a three dimensional letter.

This style is called drop shadow and is a variation on the shortcut method. To create a drop shadow, form the 3-D the same way you did before, just don't connect the corners.

STEP 1. First draw a bubble letter "N" on a piece of paper. Then place a clean sheet of paper on top and trace the bubble letter "N".

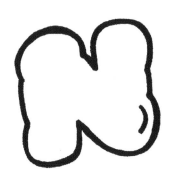

STEP 2. Next, move the top paper a little bit in any direction and trace the letter a second time, overlapping the first letter. Don't connect the corners.

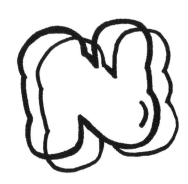

STEP 3. Erase the lines that are overlapping. You letters will look like one is in front of the other. Darken in the 3-D.

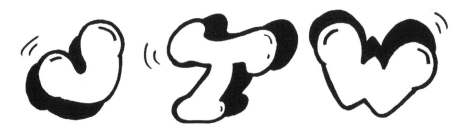

The 3-D shortcut method works the same way with a whole word. Once you master this technique you will be amazed at how easy it is to add 3-D to all of your letters. Construct the 3-D facing in any direction that you want.

STEP 1. First draw the word "3 -D" in bubble letters. Then place a clean sheet of paper on top and trace the word "3-D".

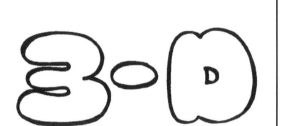

STEP 2. Next, move the top paper a little bit in any direction and trace the word a second time, overlapping the first word.

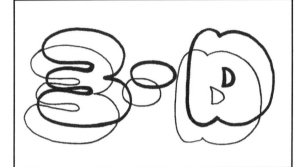

STEP 3. Erase the lines that are overlapping. Your word will look like this, with one in front of the other.

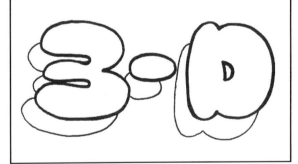

STEP 4. Draw lines to connect the corners of the two words. Erase any unneeded lines. Your word is now three dimensional.

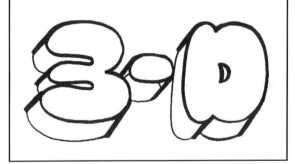

STEP 5. Draw all around the outside edges with a dark line. Smooth over all the corners and make the letter soft and bubbly. Shade in the 3-D to give your letters lots of depth.

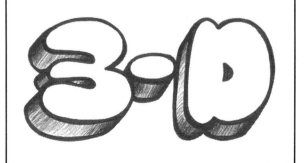

One more whole word bubble letter example. It's good to practice.

STEP 1. Write the word "ART" and then trace it on a clean sheet of paper.

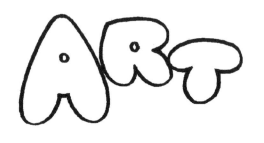

STEP 2. Move the top paper slightly in any direction and trace the word again, overlapping the first one.

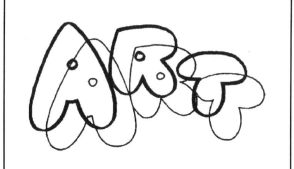

STEP 3. Erase the lines that are overlapping. Your drawing will look like one word is in front of the other.

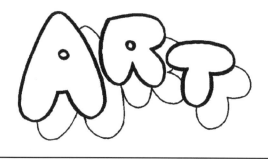

STEP 4. Draw lines to connect all of the corners and erase any unnecessary lines.

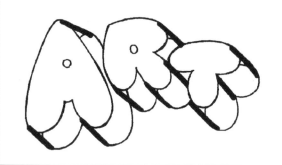

STEP 5. Draw all around the edges of your letters with a dark line, rounding off and smoothing all of the corners. Add some lines for shading to give your letters more depth.

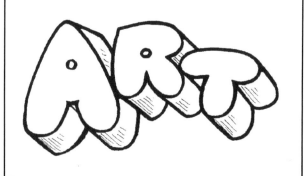

184

Now, add 3-D to this wildstyler letter. This example is a little more complicated.

STEP 1. Trace the letter on a clean sheet of paper.

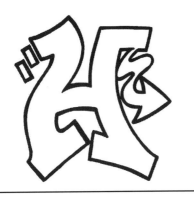

STEP 2. Move the paper slightly and trace it again.

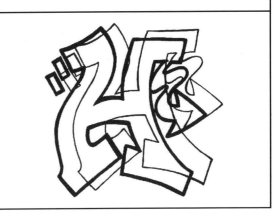

STEP 3. Erase the overlapping lines.

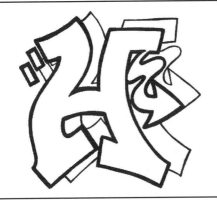

STEP 4. Draw dark lines to connect the corners.

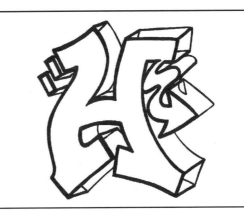

STEP 5. Erase any unneeded lines and shade in the 3-D.

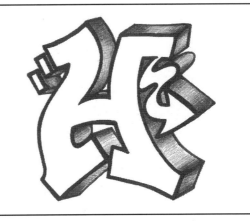

Now that you have become an expert on 3-D, you can begin to add 3-D to your letters by eye without the use of guidelines. The example below shows you how to do it. (You can point the lines in any direction.)

STEP 1.
Draw straight, equally sized lines pointing down from the bottom corners of each letter.

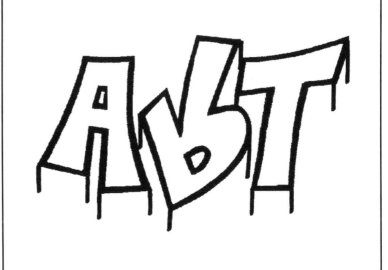

STEP 2.
Connect the ends of all the lines to form the sides and bottoms, following the shapes of the letters.

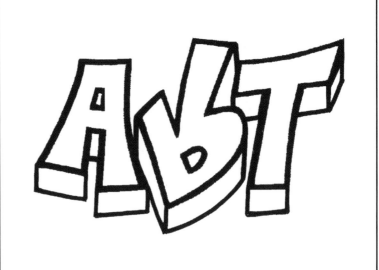

In conclusion, no matter which technique you use, adding 3-D to your letters will make them animated and give them life.

ROTATING EACH LETTER INDEPENDENTLY

Here's a totally different spin (pun intended) on adding 3-D to your letters. It's a great alternative to standard 3-D.

Using either the shortcut method or a vanishing point, form the 3-D on each letter separately. Turn each letter in a different direction so that each one looks as if it is rotating independently on its on axis. Tilt each letter on an extreme angle to exaggerate the effect. Start with basic bubble letters or block letters. Once you master this technique you can try applying it to more complex letters.

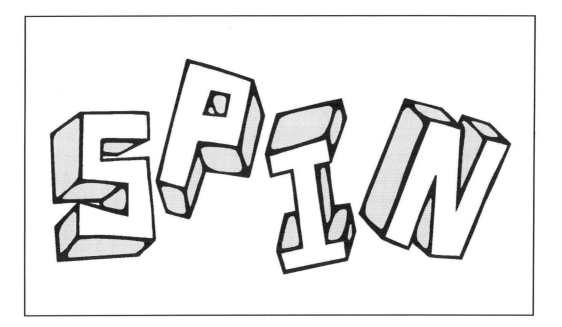

Try experimenting with 3-D effects and stretch them as far as you can. Don't worry if some of your experiments don't work - just keep playing with the techniques. Eventually you may discover innovative ways to use 3-D that no one else has thought of.

SECTION FIVE

ELEMENTS
IN A
PIECE

CHAPTER THIRTY
WHAT'S IN A GRAFFITI PIECE?

In this book there are many examples of graffiti pieces, from simple bubble letter pieces to more complex wildstyle pieces. We have brought them all together in one place to demonstrate that regardless of your skill level or style of graffiti piece you are drawing, they are all constructed using a similar set of steps. In its purest form a graffiti piece has large outline letters filled in with some sort of decoration. The whole word has a structure to it, a shape and a form. It has movement and flow. In our interpretation of a piece the letters are surrounded by a force-field. A piece has a large outline shape, like a cloud or a splash. A piece contains a mixture of popular graffiti elements or embellishments such as drips, splashes, arrows, stars, crowns, hearts, bubbles or characters.

We have developed the construction of a piece into a kind of formula so that anyone can create one. First we will show you how to construct a piece from start to finish. Then we will look at the different elements you can add to your pieces in detail. Our examples start out simply and build in complexity so that you can see how the process works with different skill levels.

COMPLETED WILDSTYLE PIECE

CONSTRUCTION OF A PIECE

STEP 1. Draw a name with any style of letters. This is the step where you modify the letters any way that you want. Add arrows, extensions, connections or bits. We are using plain block letters for this example.

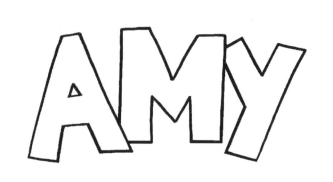

STEP 2. Add 3-D to the letters using one of the techniques we covered in Section Four - adding 3-D is totally optional.

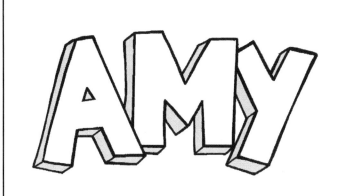

STEP 3. Draw patterns and decorations inside the letters.

Draw a force-field around the whole name following closely the shape of the letters. A force-field will help to define and emphasize the shape of the whole name.

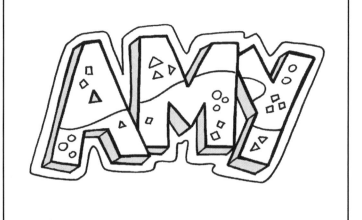

STEP 4.
Draw a large cloud around the name.

STEP 5.
Begin to add smaller elements like drips, arrows or a #1 symbol.

STEP 6. Draw flames along the bottom to create a background. Draw some small bubbles on the edges of the cloud shape.

A background can be anything you want - a city scene, a starry sky, some abstract shapes, flames, trees and flowers, more clouds, etc... The goal is to fill up the space in your picture and make it look interesting.

This is your final step to complete this piece. Look over the details carefully. Notice how all of the small elements fill up the space. The most important element in a graffiti design is the name or word, and small elements are added all around to accentuate it and create drama.

STEP 7. To finish off this piece, add more embellishments – three small hearts on the left side, wet drops splashing off the name on the right side, a crown on top, and a smiling sun for a character.

Now let's construct a wildstyle piece. The process is the same.

STEP 1. Draw a word or name with wildstyle letters.

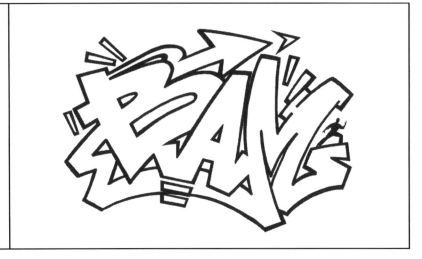

STEP 2. Add 3-D to the letters using one of the techniques we covered in Section Four.

Again, adding 3-D is optional. You don't need it for a piece, but it adds a lot of drama.

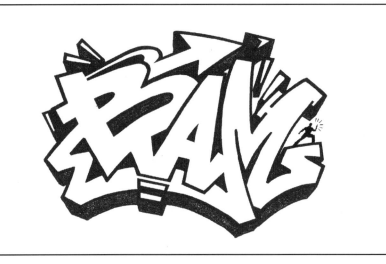

STEP 3. Draw a force-field around the whole word closely following the shape of the letters.

Add a pattern and decorations inside the letters. Add some paint drips at the bottom.

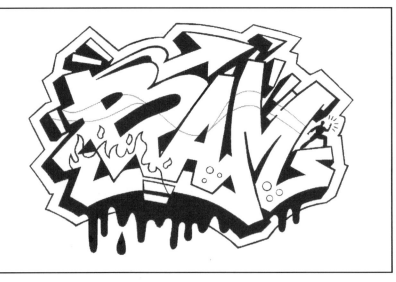

STEP 4. Add a large burst shape all around the outside of the word.

STEP 5. Add decorative elements to fill up the remaining space - flames, small arrows , lots of stars, and a lightening bolt.

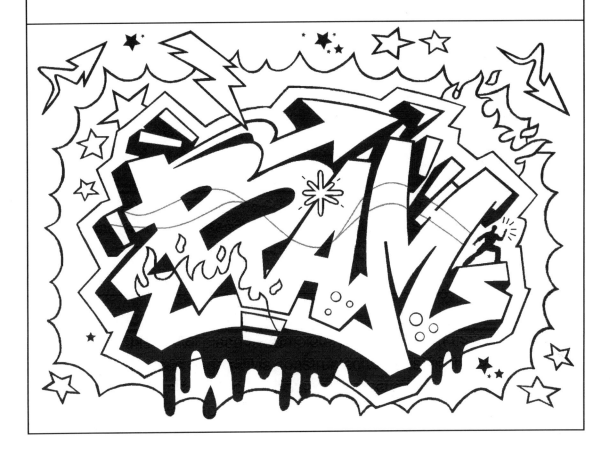

Even though this BAM" piece is completely different from the finished "ART" piece on the previous pages , it is constructed with a similar set of steps. The outline shape around the word or name can be any shape that you like: a cloud, a big splashy shape, a bursting shape, an abstract shape, a circle or rectangle. Once you have decided on your outline shape, you can fill in the rest of the spaces in your picture with any small graffiti elements that you like. The most popular small elements are bubbles, hearts and stars. Use lots of small details and get as creative as you want. Experiment! You can always start over and try different variations.

Now, let's get back to our "FUN" piece from Chapter Twenty-three.

The most important element in a graffiti piece is the lettering, so focus your attention on your letters first. Spend extra time to get your letters the way you want them. Add 3-D using one of the techniques we covered in Section Four. Although adding 3-D is completely optional, it will animate your letters and give them a lot of life. Erase any guidelines you don't need when you are done.

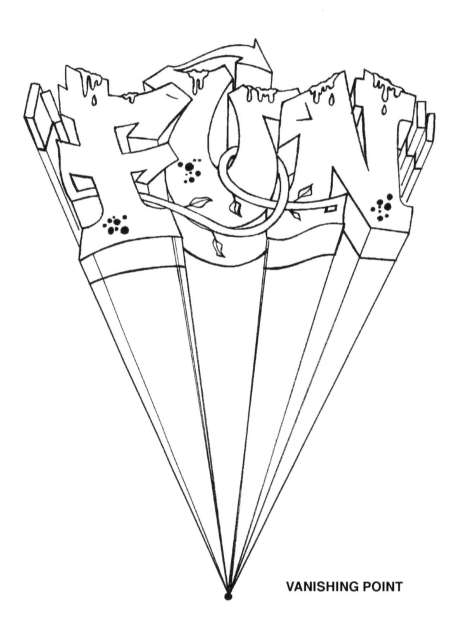

VANISHING POINT

Add lots of decorations inside the letters to make them really interesting. When you are satisfied with how your letters look, draw a force-field surrounding the whole name or word. Then complete the piece however you like.

This is our finished piece with all the elements added - letters, a force-field, a large cloud around the word, small characters playing sports along the tops of the letters, chess pieces, dice, and scrabble tiles across the bottom to fill out the design. A few cracks and bricks are added inside the letters to make them look really cool.

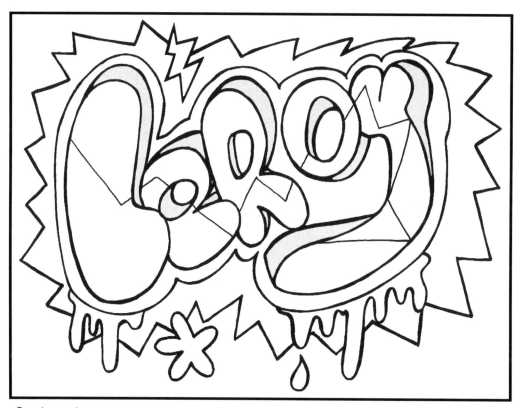

Student piece

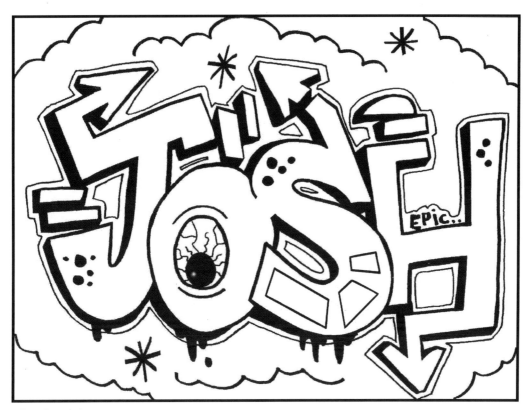

Student piece

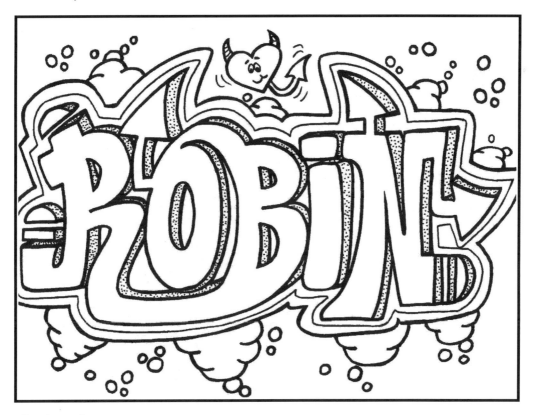

Student piece

In Summary, the building blocks needed to construct a graffiti piece are:

Letters - any style

3-D (optional)

Patterns or decorations inside the letters

Force-field around the letters

Large outline shape surrounding the whole word or name (cloud, burst, splash, abstract shape)

Assortment of drips, drops, splashes, bubbles, stars, hearts, arrows, flames, characters, and other small elements to embellish the picture and fill up the space.

The methods that you use to build your pieces are very flexible, so try them all out and select the techniques that work best for you. We go back and forth between using a vanishing point and the 3-D shortcut method all the time. Sometimes we use a large outline shape and other times we add smaller shapes sticking out from the edges.

In the next chapters we will examine the individual graffiti elements more closely and look at a variety of interesting ways you can arrange them in your picture.

CHAPTER THIRTY-ONE
CLOUDS

Old school graffiti writers took inspiration for their pieces from many different places. The illustrations inside comic books were a great source of ideas, as well as album covers. In those days album cover art was a really big deal. Comic books were filled with all kinds of expressive lettering devices such as clouds and word bubbles that could be adapted for elements in a graffiti piece.

Clouds are found everywhere in graffiti art. The nice thing about clouds is that they are easy to draw and can be used in both tags and pieces. You can draw clouds in any shape or size that you want. In this chapter you will find some suggestions for different ways to use clouds in your pieces. There is a cloud pattern at the end of this book that you can assemble and turn into a reusable stencil that you can trace. Or just draw your clouds freehand. They are easy to do.

Draw a word inside a large cloud.	Draw several small clouds behind a word.
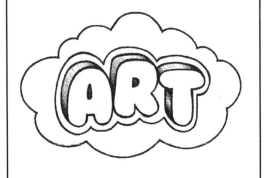	

Draw clouds coming out of the corners.

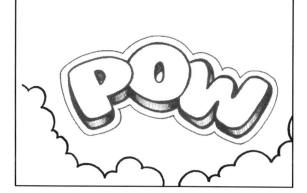

Draw a cloud in a diagonal position with the end extending off the edge of the paper. This is a more dynamic composition.

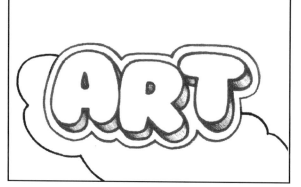

Draw cloud borders across the page with a word in between.

Draw lots of clouds in layers to fill up the page.

Draw little sections of clouds poking out from each side of a word. This is a great technique to jazz up your piece. Then draw lots of little circles for bubbles. Use bubbles all over your piece to fill up empty spaces and add complexity and interest. You can't have enough bubbles. Draw clumps of bubbles and single bubbles. Draw them any size you want.

Here's a fun technique. Create a cloud by drawing a bunch of small, overlapping circles with a circle template. Then draw around the outside edges with a dark line and erase all the inside guidelines. Put your name inside.

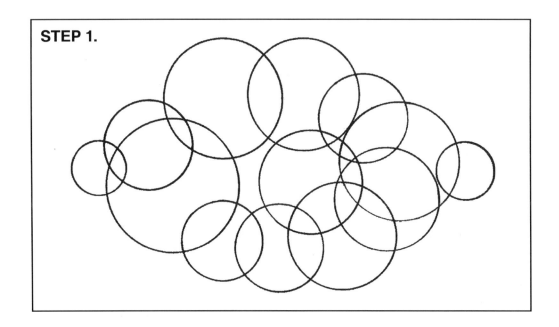

CHAPTER THIRTY-TWO
DRIPS, DROPS AND SPLASHES

We are really enthusiastic about paint drips. The wetter and drippier they are, the better. This brings us back to tags. In Section One, we showed you how to design your own tags, but we left out the part about paint drips. Paint drips are a unique aspect of tag lettering. To create drips, a special kind of magic marker called a mop is overfilled with some type of watery, free-flowing ink and is applied to a vertical surface to write a name. The drips, drops and splashes that result from this messy, energetic writing become part of the tag's design. So paint drips are spontaneous and they happen naturally as a result of using a wet marker or brush.

Back in the early days of graffiti, writers really liked the effects of dripping and splashing in their tags, so they invented ways to use them in their pieces as well. Today drips, drops and splashes are a standard graphic element in graffiti designs. This chapter will show you how to use them. At the end of the chapter, we'll give you some suggestions on how to make your own drip, drop and splash reference pages which you can save and use for future projects. Personally, we keep stacks of dry, drippy design pages in our files that we constantly refer to for inspiration.

Here are some traditional ways to use paint drips in your pieces. Don't hesitate to fill up your picture with lots of extra drips and drops.

Draw drips across the top of the page.

Draw paint dripping off the bottom of a word.

Use a combination of drips and clouds. Draw drips hanging off the letters and everywhere else. Make a wet, drippy mess. Drips look good no matter what.

Use a combination of large drips, small drips and clouds to make an interesting composition. Draw extra drops hanging off the ends of the drips.

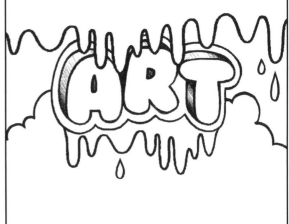

Draw big splashes with drips and drops shooting off in all directions to make your piece look really wet and juicy. Draw splashes in wild, exciting shapes.

Draw a word inside a splash. Add drops.

Draw small splashes around a word. Add lots of extra drops. Put accent words inside the splashes.

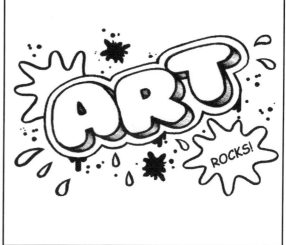

Combine a large cloud or large splash and drips into one shape. Put your word in the middle.

Draw a splash pointing down, with the edges of the word bursting out of it. Add lots of drops.

CREATE YOUR OWN DRIPPY REFERENCE PAGES

Experiment with making your own drips, drops and splashes. You can use any kind of paint or ink. Just be sure to cover your work area with a plastic tablecloth or kraft paper first. Be really careful and considerate. This is a messy and sloppy activity, but lots of fun. Clean up any drops that stray off the paper immediately before they dry.

Next, load up a paintbrush with watery ink or paint. Then flick it onto your paper. Aim the drips towards the top edge and then tilt your paper so that the ink runs downward to create cool looking drips. For splashes, hold the paint container a few inches above your paper and pour out a few drops. The higher you hold it, the bigger the splash pattern. Use heavy-weight paper because this exercise is extremely wet. Or use multiple layers of regular paper so that your surface is thick and sturdy. Try flicking an old toothbrush with your finger to make lots of tiny, little splatters. When the paint dries, you'll have a unique, reusable collection of drip and splat patterns that you can either trace directly from or scan into your computer. Or take a photograph and download it, then cut and paste the parts that you want into your drawings. You can cover the drip and splash pages with clear contact paper or plastic laminate to preserve them if you want. With practice you can control where and how the drips flow and manipulate them for different effects. We prefer to work with India ink because it is so fluid. We prefer black, because it is the easiest color to photograph, scan or trace. But you can use any colors that you like or use multiple colors to create interesting effects.

CHAPTER THIRTY-THREE
FLAMES

This book on graffiti pieces would not be complete without a chapter on flames. As a matter of fact, graffiti pieces are sometimes called "burners". Burners are large-scale pieces that have bold, bright colors that radiate with energy. They burn off your page. Burners are eye-catching, flamboyant, and dramatic. They have imaginative letters with lots of interesting details. And what better way to make your piece sizzle and burn than to accentuate your letters with blazing flames.

Flames can be added to a piece with any style of letters. Look on the internet at pictures of old cars from the 1950's and tatto designs to get ideas for flame patterns. Draw lots of flames to make your picture look super hot.

Cropping your picture and framing it in interesting ways adds lots of drama to your picture.

Add shooting flames in the corners, the background, or in the letters.

Try these different ways to add flames to your pieces.

Draw a flame border across the bottom of the page.

Draw flames in the corners and flames attached to the force-field.

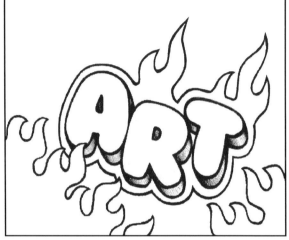

Draw flames shooting off the top of a word.

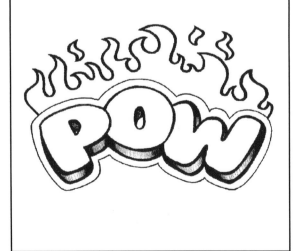

Draw flames shooting out from behind a large cloud and flaming letters.

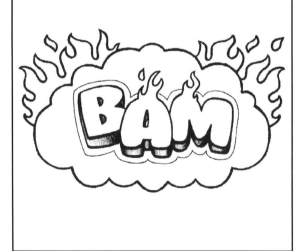

CHAPTER THIRTY-FOUR
BURSTS

How about a burst of energy, a burst of color, or a burst of light? Think super nova, fireworks, and explosions. That's the kind of energy you want to put into your graffiti pieces. The drawings below show you some examples of how to use bursts in your pieces.

Draw a word inside a big, explosive bursting shape. Draw stars shooting off the edges.

Draw lots of small bursts all around your letters. Write accent words inside the tiny bursts.

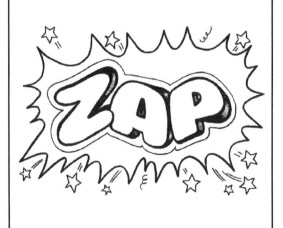

Old School Piece

A small burst exploding out from behind the letters is a great way to add small accent words to your piece. This piece includes just about everything we have covered so far: bubbles, drips, 3-D, force-field, border clouds, etc...

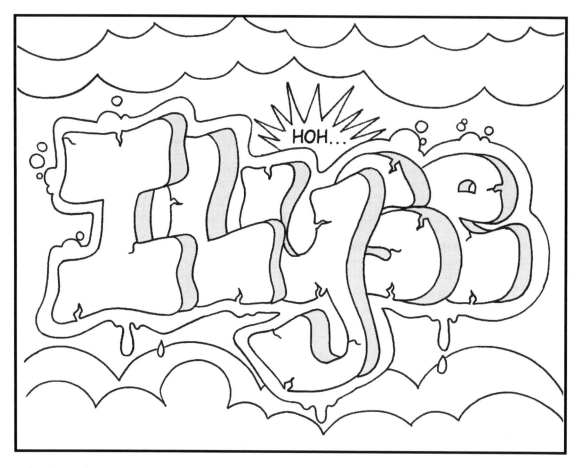

Student piece

Arrows are an essential element in graffiti art and originated with tag lettering. In tag lettering, arrows tend to flow naturally and spontaneously from the ends of the strokes of letters, as in the examples below. But arrows can also be added to other elements, such as clouds or force-fields.

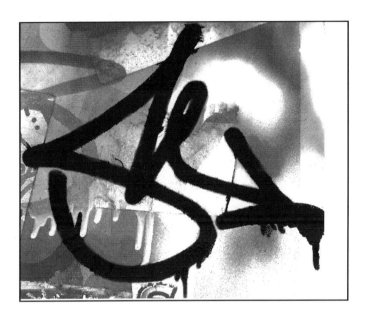

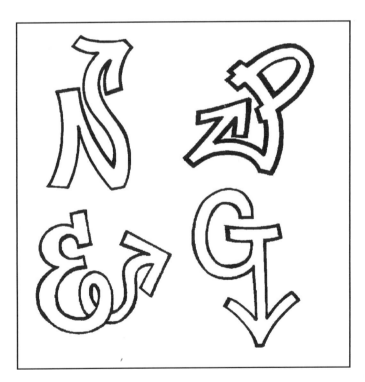

Or they can be free standing and separate objects. Arrows give power and emphasis to your piece and add lots of movement and energy. Arrows can be drawn in all shapes and sizes. Eventually, with practice you will develop your own arrow style which will become a vital part of your personal graffiti toolbox.

Add an arrow to a letter, a force-field or a large outline shape. Make the head of the arrow rounded, squared or pointy.

You can attach an arrow to any part of a finished letter.

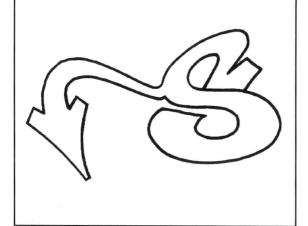

Draw an arrow attached to the end of a long serif.

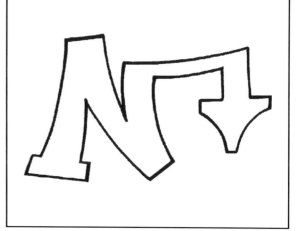

Combine an arrow with a large outline shape.

Attach an arrow to a force-field.

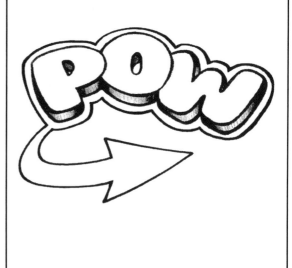

Here are some interesting arrow variations you can put in your tags.

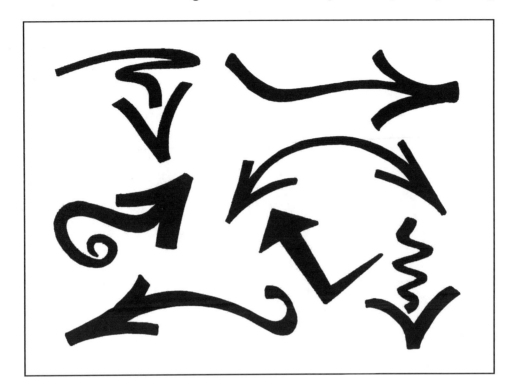

Then use bars to fatten them up into outline arrows and put them in your pieces.

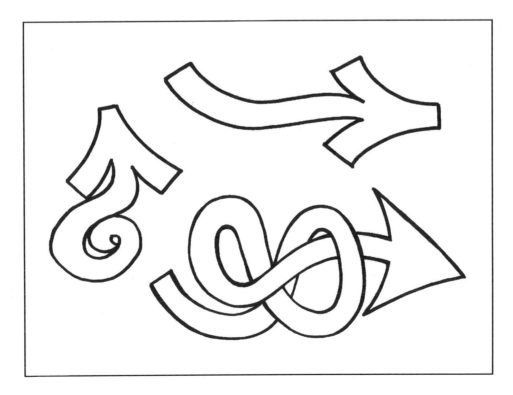

Experiment with putting arrows anywhere in your design that you like. Remember that arrows add motion and energy to your letters and create flair and style in your finished pieces.

Student piece

Student piece

CHAPTER THIRTY-SIX
MISCELLANEOUS ELEMENTS

Graffiti is art made with words. It is a visual language with its own unique set of symbols. Over time those symbols have become standardized graffiti elements that everyone uses to build their graffiti pieces.

In this chapter we present a collection of additional popular elements that you can experiment with. They are basic and simple, but vitally important. You can trace them straight from this book if you like or draw them yourself. Crowns are a great place to start. You can draw crowns in any shape or style. Crowns are often found in tags, but also work really great in pieces.

Stars come in all shapes and sizes. Put stars everywhere on your piece. Draw a flaming star. Or a shooting star. Or a lightening bolt.

Hearts are so versatile and look good on anything. Who doesn't LOVE hearts in a piece! Draw a drippy heart. Or a broken heart. Or a devil heart. XOXOXOXOXOXOXOXOXOXOXOXOXOXO

Add a symbol to your piece. A © copyright symbol is especially popular. Or a $ dollar sign. Or "quotation marks". Or a peace sign. This is just a sampling of the infinite variety of symbols you can put into your pieces. Take inspiration from everywhere.

Characters add more animation to your piece. They can be simple smiley faces and cartoon skulls, or realistic animals and people. Draw them doing stuff, like playing ball or skateboarding. We get lots of ideas from "How To Draw" books. You just need to draw cartoony looking eyes on an object or animal to bring it to life.

Last but not least, are backgrounds.

A background is a way to tie all of the elements in your piece together. A background can be anything you like - a city scene, an abstract pattern, a brick wall, or a combination of several different elements. You can add anything else to your picture that you want to create interest and fill up the space. Your goal is to create an exciting graffiti design. The rules are - there are no rules. Just use your imagination, experiment and have fun!

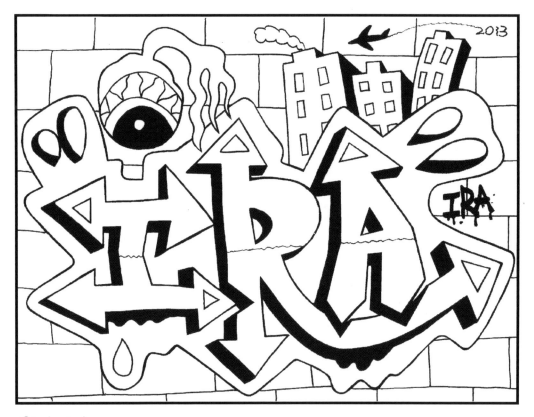

Student piece

Next up - patterns and decorations inside the letters, finally!

CHAPTER THIRTY-SEVEN
PATTERNS INSIDE LETTERS

Let's take a look at a bit of history. In the early days of graffiti, a masterpiece had basic outline letters filled in with some sort of simple decorations. The graffiti term for these decorations is "fill". At first these decorations or fills were really basic. They consisted of little stars, hearts, dots, or stripes that looked like candy canes, arranged evenly around the insides of letters. These early pieces may look kind of primitive today, but back then those concepts were groundbreaking. Other graffiti writers saw these awesome decorated pieces and quickly adopted them, elaborating on them and adding their own ideas and innovations. Guidelines and formats were standardized. Soon the foundations of graffiti as an artform were thoroughly established. Design elements that were repeated over and over again, such as clouds and arrows, became standardized motifs that most graffiti artists still use today. It's astounding to look at the complex graffiti pieces of today with their elaborate textural patterns, intricate details and masterful piecing, and realize that it all started back then with those simple designs.

In this chapter we illustrate some of the classic designs and patterns that graffiti artists often use to decorate their letters. You can use our examples as a guide, then create some of your own. Make up any fun, zany patterns that you like. Look on the internet for ideas. Decorating your letters will jazz them up and put your pieces over the top, amazing everyone who sees them. For now let's just focus on using black, grey and white. Then in the next chapter we'll explore adding color.

EXAMPLES OF FILLS

EXAMPLE
ONE:

Draw clouds
inside the
letters.

EXAMPLE
TWO:

Draw flames
inside the
letters.

EXAMPLE THREE:

Draw drips across the tops of the letters.

EXAMPLE FOUR:

Draw wavy lines acoss the letters and fill them in with different colors. Make them as thick or thin as you want.

EXAPLE FIVE:

We call this style "Inline". Draw around the inside edges of each letter all the way around. Color in the centers.

EXAMPLE SIX:

Draw a big lump of drippy snow or melting goop on top of each letter. Draw a few drops falling down.

EXAMPLE SEVEN:

These letters are filled with bubbles. Draw curvy shapes to form groups of bubbles with lots of little circles for single bubbles.

EXAMPLE EIGHT:

Draw small groups of bricks in different areas. Follow the shapes of the letters using the outer edges as a guide.

EXAMPLE
NINE:

Draw a
cracked
cement wall
with paint
peeling off
and bricks
showing
through in
patches.

EXAMPLE
TEN:

Draw a
graded
pattern from
light to dark.

EXAMPLE ELEVEN:

Draw shaded sections folllowing the shapes of the letters along the top. Add cracks along the side and bottom edges.

EXAMPLE TWELVE:

Draw a random pattern with alternating washes of light and dark colors, bubbles and abstract shapes.

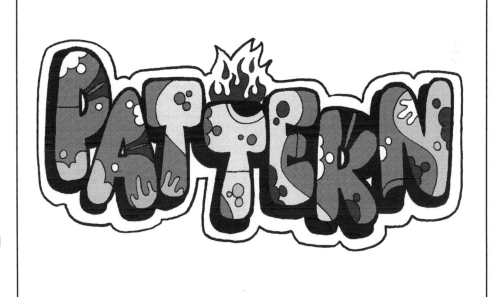

You can make all kinds of fun stripes using a ruler. In these examples straight lines are drawn on top of the letters and filled in to create different effects.

EXAMPLE THIRTEEN:

With a ruler, draw a starburst pattern and fill it in with alternating colors.

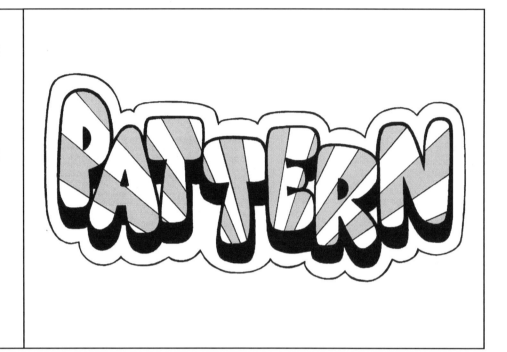

EXAMPLE FOURTEEN:

Draw stripes across your letters and fill them in with the same colors all the way across. Use the colors of the rainbow: Red, Orange, Yellow, Green, Blue, Purple

232

Example #15 is drawn by tracing an animal print from a picture onto the letters. There are so many more patterns you can create. Try everything. It's all good.

EXAMPLE FIFTEEN:

Draw an animal print. You can copy or trace a design from a picture or make up your own animal print.

EXAMPLE SIXTEEN:
Draw stripes across the letters and arrange colors differently in each letter. Mix it up so no two colors are the same that are next to each other. Add bubbles on top.

"Highlights" are areas or spots in a drawing, painting, or photograph that reflect light. They usually go on the opposite side of the letter from where you put your 3-D. The more contrast you make between the dark and light areas in your letters, the shinier the highlight will be. A white paint marker is a great tool to have on hand for drawing highlights.

| EXAMPLE SEVENTEEN:

Highlights can be soft and fuzzy lines drawn around the inside edges of the letters. Put all of your highlights on the same side. | |

| EXAMPLE EIGHTEEN:

Highlights can be sharp, white spots that strongly reflect light. Adding bright highlights to your letters will give them energy and pizzazz.
This highlight looks like a star shining brightly in a night sky. | |

After you have designed your letters, pieced them, added your clouds and any other elements you want in your piece, it's time to think about color. Graffiti pieces are explosive, exciting designs that are filled with dynamic, eye-popping colors. And the way to make colors pop is by using contrasting colors in the same piece. But what exactly are contrasting colors? Contrasting colors are called complementary colors. Complementary colors are pairs of colors that are opposite each other on the color wheel. Colors that are opposite each other on the color wheel are said to clash. This clashing is what makes the colors pop. Clashing colors are not necessarily a bad thing. They just have a strong visual impact.

Don't worry if it sounds a little complicated. We'll show you how to easily figure out which colors are complements of each other and give you some ideas for how to use these colors in your pieces. We'll start out with a basic color wheel on the next page. A color wheel is a tool people use to help organize and learn about color. It's simply a circle divided into segments. The wheel shows you how the six basic colors of the rainbow relate to and interact with each other and which pairs of colors are complements.

COLORS OF THE RAINBOW

RED - ORANGE - YELLOW - GREEN - BLUE - PURPLE

PRIMARY COLORS

THESE ARE THE THREE PRIMARY COLORS

PRIMARY COLORS
RED
YELLOW
BLUE

Primary colors cannot be made from other colors.

IF YOU MIX TWO PRIMARY COLORS TOGETHER YOU GET SECONDARY COLORS

SECONDARY COLORS
Red + Yellow = Orange
Yellow + Blue = Green
Blue + Red = Purple

COMPLEMENTARY COLORS

If you draw an arrow directly across the color wheel from one color to another, you will find its opposite or complementary color.

The complement of yellow is purple.

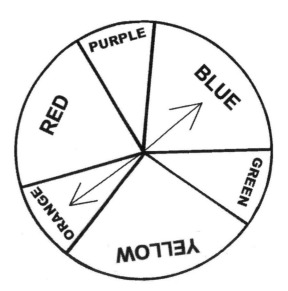

The complement of blue is orange.

COMPLEMENTARY COLOR PAIRS

Blue and Orange
Red and Green
Yellow and Purple

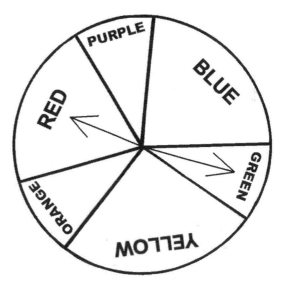

The complement of red is green.

The complement of each primary color (red, blue, or yellow) is roughly the color made by mixing the other two primary colors together.

How to Use Complementary Colors in Your Pieces

The concept here is that if you put a color and its complement near each other in a picture, it will make the colors in the picture "pop" or vibrate. In addition, if you put those colors on a neutral background, like grey, brown, black or white, this will make the colors pop even more. The word "POP" on the facing page is drawn in three dimensional bubble letters with a force-field on top of a neutral, grey background. The color combinations below consist of the six basic colors of the rainbow arranged as complementary pairs. Make copies of the "POP" drawing and experiment with placing the complementary color combinations listed below in the drawing as instructed. Or you can use a similar drawing of your own and experiment on that instead. Notice how the colors work together.

Put **red** in the letters and **green** in the force-field

or

Put **green** in the letters and **red** in the force-field

Put **yellow** in the letters and **purple** in the force-field

or

Put **purple** in the letters and **yellow** in the force-field

Put **orange** in the letters and **blue** in the force-field

or

Put **blue** in the letters and **orange** in the force-field

Try these complementary color combinations for yourself and see how you like the effects. Do they pop? Which combinations do you like the best?

You can use complementary pairs of colors in any section of your pieces. You can put them in the large outline shapes, the 3-D or the background. No matter where you put them, the high contrast of complementary colors creates a vibrant look that will imbue your picture with energy.

To make complementary colors vibrate even more, you can also alternate the intensity of your colors. In other words, you can pair a bright, dark red with a pale celery green, or a soft peachy orange with a dark midnight blue, or a light lilac purple with a deep, burnt yellow. The more opposite the colors are the more they will pop. Color popping is the secret to making graffiti art that is exciting and dynamic. Have you ever seen a large graffiti piece that looks like it will jump off the page or wall and wondered how it looks so vibrant? The secret is color popping!

Tips for Coloring Your Graffiti Piece

1. Graffiti art is all about vibrant color. You can use whichever coloring tools you prefer or that you have on hand. Crayons, colored pencils and magic markers all work great in different situations. For tiny little details, try using colored pencils or magic markers with fine points. For large areas, magic markers with wide tips or crayons work well.

2. Mixed media - you can use a combination of pencils, markers and crayons in your piece if you like. Experimentation is the only way to find out what works best. The great part is that with practice your skills and technique will improve significantly.

3. Don't worry if you go outside the lines when you color. You can always color in the background of your piece to hide places where you went outside the lines. Add two force-fields or even three in different colors to hide or blend in mistakes.

4. Pressing down lighter or harder on your pencils and crayons can give you interesting effects. Our favorite technique is to color around the edges of a shape darkly and then color the middle in lighter tones with the same crayon or colored pencil.

5. Use warm colors red, yellow, and orange to make your picture hot. Warm colors are associated with fire and the sun.

6. Use cool colors blue, green and purple to give your picture a calm, soothing feeling. Cool colors are associated with water, sky and nature.

7. Try using lighter or darker versions of the same color in sections of your picture that are next to each other. For example, use pink next to red or sky blue next to dark, royal blue.

8. Try stippling or crosshatching. Stippling means drawing lots of little dots inside a shape to fill it in. Crosshatching means drawing lots of little lines in different directions, and overlapping them like little "X's" to fill in a shape. The more dots or lines you draw, the darker the color and shape will get.

9. Use layers to build intensity in your colors. First color one layer with all of your lines going in one direction, then do another layer with your lines going in a different direction.

10. Color in a shape with different tones of the same color in rings or consecutive circles. For example, put orange in the outer ring, yellow in the middle ring, and light yellow inside the center ring.

11. Blend colors together by fading the edges of one color into another. This works especially well with alcohol-based markers, because it takes a little longer for them to dry and you can blend the edges of the colors together easily.

12. Start by applying the lightest colors first, and then gradually apply darker colors. You can use a white paint marker on top of darker colors to add highlights to your letters.

SECTION SIX

GRAFFITI
ART
PARTY

HOW TO THROW A GRAFFITI ART PARTY

DRAWING INDIVIDUAL PIECES

Drawing graffiti pieces is a great party activity for a small group. This book provides the tools and instructions you'll need to have a successful graffiti art party. In our experience, just about everyone wants to learn how to draw their name or someone else's in graffiti style letters. The techniques and projects in this book can be tailored to meet the requirements of any group. The age of the participants and the time allotted to finish the project all need to be taken into account when planning your activity. Also you'll need to set aside time to prepare materials beforehand. This book is designed as a user-friendly manual and guide to demystify the graffiti-making process, so you'll want to have it on hand during your party for everyone to refer to for ideas. Please read through the entire book before you start your planning to familiarize yourself with all of the techniques. Then you can gather and assemble the materials you'll need for your party, following the instructions in this chapter. We want everyone to be able to make a successful graffiti piece and have fun in the process. With good preparation and planning your graffiti art party will be a memorable event.

CREATING A GROUP MURAL

Sometimes graffiti artists work together to collaborate on murals and other large-scale projects. They travel around to create graffiti art with friends and fellow writers and form "crews" with other artists who become life-long colleagues and friends. So making a large graffiti group project is a fun alternative to having each member draw their own piece. You will need a roll of large, wide, heavy-duty paper. You can place the paper on the floor or on a long table and have your party members make a mural. Or you can hang the large paper up on a wall and have your party members draw their graffiti standing up.

Either you can design a giant piece beforehand or have them all do individual pieces on the same paper using the instructional materials provided in this book. The finished mural will be a keepsake that you can store away and treasure for years to come.

So, Where to Begin

Get all of your materials ready before your graffiti party begins. You can either have your table set up for your guests before they arrive or bring out the supplies later on. We recommend using bubble letters to draw the names, because bubble letters are fairly easy to draw and many people are familiar with them. But that's just our preference. Use any letter style that you feel comfortable with. Either you can draw the names of your party participants in bubble letters beforehand and have the group work on adding a cloud, spalsh or other elements to finish their pieces. Or you can have everyone draw their own names with bubble letters, which will take a lot more time. Have extra paper available in case someone wants to start over. There are bubble letter handouts at the end of this chapter that you can remove from the book for instruction. Make extra copies to have on hand for everyone to look at to help them draw their letters. Explain to the group that they should begin to sketch out the elements they want to have in their pieces lightly with pencil. Have some cheap copy paper on hand for anyone who wants to practice first before using their good drawing paper. Show your group the examples in this book so they can get some ideas for ways to arrange their elements and decorate their letters. This chapter contains patterns to make large cloud and splash stencils that you can give out to each participant. Now they have a choice. Either your party guests can trace the large cloud or splash first with a pencil and put the letters of their names inside the shape. Or they can draw their names first and then trace the cloud or splash shape on top to fit around the letters. Either way works well. Remember that there are many different ways and methods to draw graffiti besides those in this book, so encourage everyone to create their piece however they like. Once everyone has finished their pencil drawing, it's time to apply color. Color the pieces any way you like and add stickers to finish them off. Darkening the

outlines with a permanent black marker is optional and can be time consuming and frustrating, so skipping that step and working with just pencil outlines is fine for younger children. There are plenty of free graffiti coloring pages and free lessons with printable handouts on our website *@graffitidiplomacy.com* so you can have extra graffiti-themed materials on hand to pass out. Also there are examples of full color pieces on our website to give you ideas. To have a really successful graffiti art party and be able to help your party guests create dynamic graffiti pieces, you should definitely read this whole book and practice drawing a simple graffiti piece yourself. Remember to keep your art activity lighthearted and fun, because it is a party after all.

What You Will Need

1. White heavy- duty drawing paper or white cardstock - at least 9"x12" or larger.

2. Crayons, magic markers, colored pencils - you can have just one or all three of these.

3. #2 pencils, pencil sharpeners, extra erasers.

4. Cloud and splash patterns from this book.

5. Oaktag or cardstock to make cloud and splash stencils.

6. Assortment of stickers.

7. This book.

8. Scissors, white school glue and scotch tape.

9. Bubble letter handouts from this book.

Optional: A new pointy black marker for each participant - if you decide to use Sharpies, remember that they are permanent and bleed through paper. They will **stain** your table, so you need to have a board of some kind underneath everyone's drawing paper. Sharpies work best, because they do not smear when you erase or color over them. Make sure you purchase Fine Point Sharpies if you decide to use them. Flares and Pilot markers are also great, but take a bit longer to dry and aren't water-proof so they smear.

Note #1: We suggest giving a new, small box of 16 crayons to each participant. A box of crayons is reasonably priced and makes a great party favor. For older kids, a box of colored pencils is a great alternative.

Note #2: You'll need copies of the bubble letter handouts found at the end of this chapter if you want to have the participants draw their own names.

Note #3: You can use commercial alphabet stencils to draw the names instead of drawing bubble letters. This works really well when you have a limited amount of time or a younger group. Not everyone feels comfortable drawing the letters of their name on their own, so having an alternate option insures that everyone will be able to create something they are pleased with. You can find all kinds of different alphabet stencils in art supply stores or on the internet. They are not always cheap, but the plastic ones are very durable.

Note #4: You may also want to have a ruler or two on hand for those individuals who are more concerned with details such as lining up letters.

Note #5: You can use rubber stamps to decorate the drawings, too, or small pom-poms. Our favorite additional supply is wiggly eyes, which require white school glue to apply (can get messy with a large group and needs time to dry).

ASSEMBLING THE CLOUD AND SPLASH PATTERNS

First you will need to cut out and assemble the cloud and splash patterns following the instructions below and on the next page. Then you will need to trace both patterns onto a large sheet of light colored oaktag. Finally, you will need to cut out the clouds and splashes to use as stencils. You can trace and cut out as many clouds and splashes as you want. To assemble the patterns and stencils you will need scissors, white school glue and scotch tape

STEP 1. Cut out Parts A and B along dark black outline.	**STEP 2.** Spread a thin layer of glue on the dark grey sections of Part A where indicated on the pattern.

STEP 3. Attach Part A and Part B together matching the seams and the arrows. Arrows do not have to match perfectly. Pattern should lay flat.

STEP 4. Apply a small piece of scotch tape on the seams to reinforce them on the front and back.

STEP 5. Trim the overlapping edges where needed to blend the edges together.

STEP 6. Your finished pattern is ready to trace.

PREPARING YOUR CLOUD AND SPLASH STENCILS

After you have assembled the patterns you can make stencils for your party. To do this trace each of the patterns onto a piece of oaktag or cardstock and cut them out. You can cover them with clear contact paper or laminate if you like before cutting to make them really durable. Make as many duplicates as you need. You can label them with a decorative, homemade sticker that says "_____'s 12th Birthday Party" and give them out as party favors at the end of the party if you like. Or pass them on to a friend to use for their own graffiti party.

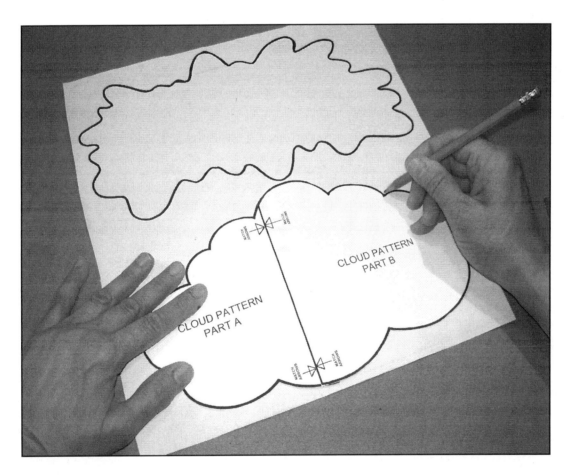

These stencils can be used exactly as they are or can be modified however you like. Feel free to design your own variations or have your guests create their own unique outline shapes.

SETTING UP YOUR ART TABLE

Lay out your table with a place setting for each person. Each setting should have a piece of good drawing paper (with or without the person's name drawn in bubble letters), a pencil, an extra eraser, a small pencil sharpener, and a box of crayons or colored pencils that can be a party favor. On the table should be placed extra coloring tools that you might like to use, such as a platter of magic markers, a platter of colored pencils, and an assortment of stickers. Lay out all of the stencils you have made. Add pre-cut, store bought stencils if you like, such as animals, cars, insects, or flowers. Kids love them all.

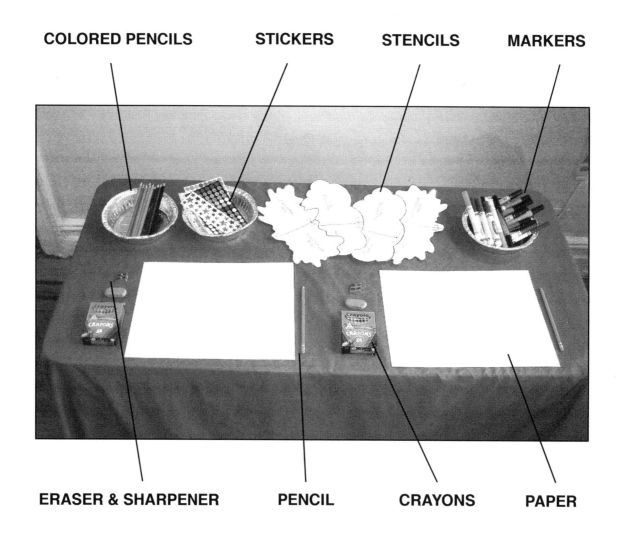

COLORED PENCILS STICKERS STENCILS MARKERS

ERASER & SHARPENER PENCIL CRAYONS PAPER

If you are going to be having people draw their own names with bubble letters, remove the bubble letter instruction sheets at the end of this chapter and make as many copies as you need. Hand them out along with the cloud and splash stencils. You can also have store bought alphabet stencils on hand if you prefer. These are just general guidelines.

HOW TO DESIGN A GRAFFITI PIECE

1. Place either a cloud or splash stencil on your paper and trace around it with a pencil.

2. Draw your name in bubble letters inside the shape or vice versa.

3. Add whatever graffiti elements you want - drips, hearts, stars, arrows, etc...

4. Color your drawing with magic markers, crayons, or colored pencils.

5. Embellish with stickers, stamps or whatever else you have on hand.

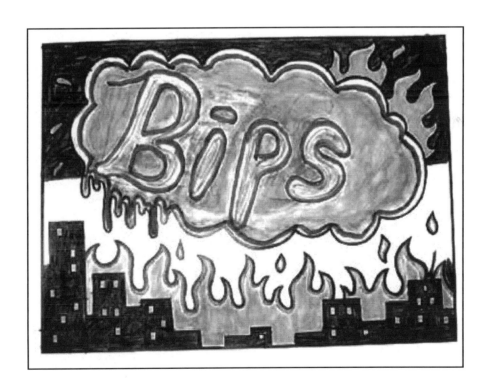

HAVE A GREAT PARTY!

PATTERN PIECES AND HAND-OUTS

The following pages contain pattern pieces to make cloud and splash stencils and bubble letter handouts.

CUT PAGE OUT ALONG DASHED LINE. CUT OUT PATTERN AND ASSEMBLE.

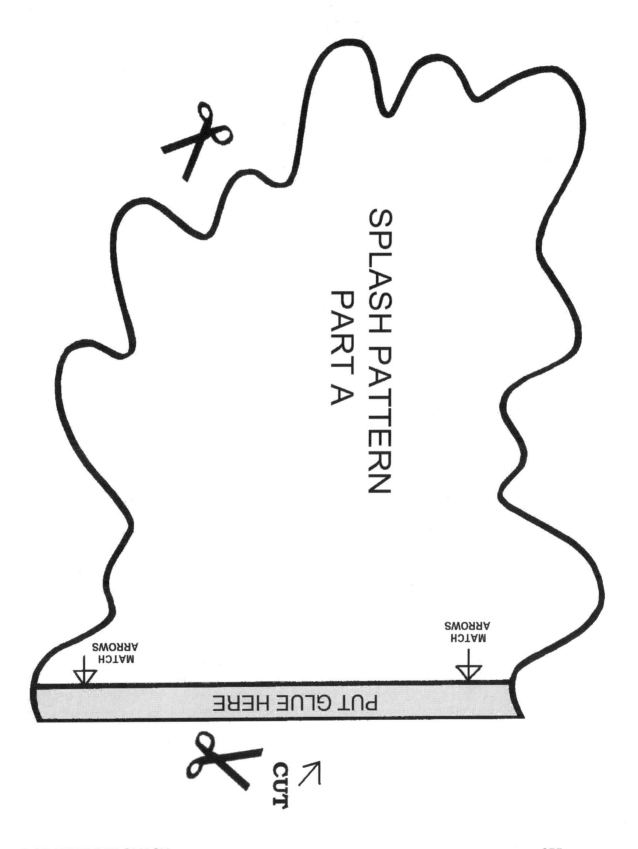

SPLASH PATTERN
PART A

MATCH
ARROWS

MATCH
ARROWS

PUT GLUE HERE

CUT

CUT PAGE OUT ALONG DASHED LINE. CUT OUT PATTERN AND ASSEMBLE.

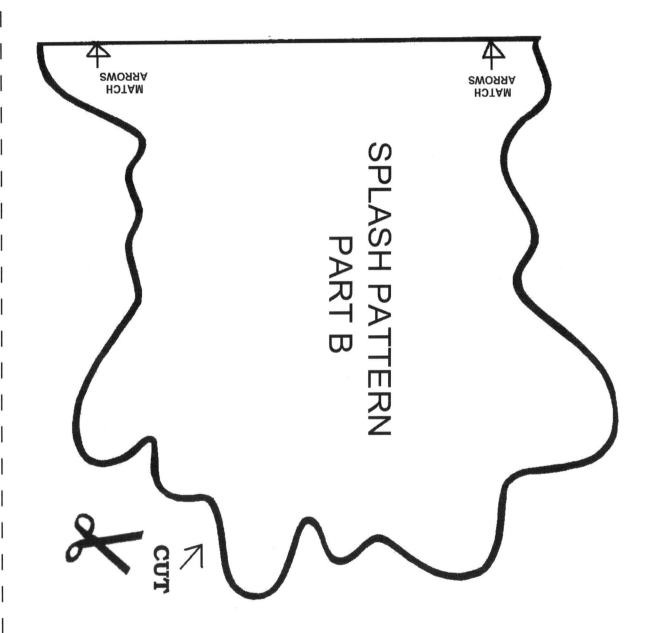

CUT PAGE OUT ALONG DASHED LINE. CUT OUT PATTERN AND ASSEMBLE.

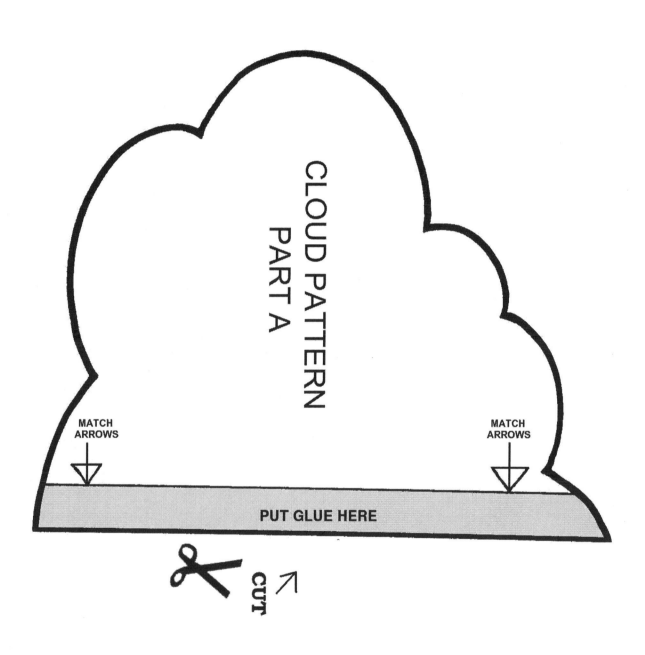

CLOUD PATTERN
PART A

MATCH
ARROWS

MATCH
ARROWS

PUT GLUE HERE

CUT

CUT PAGE OUT ALONG DASHED LINE. CUT OUT PATTERN AND ASSEMBLE.

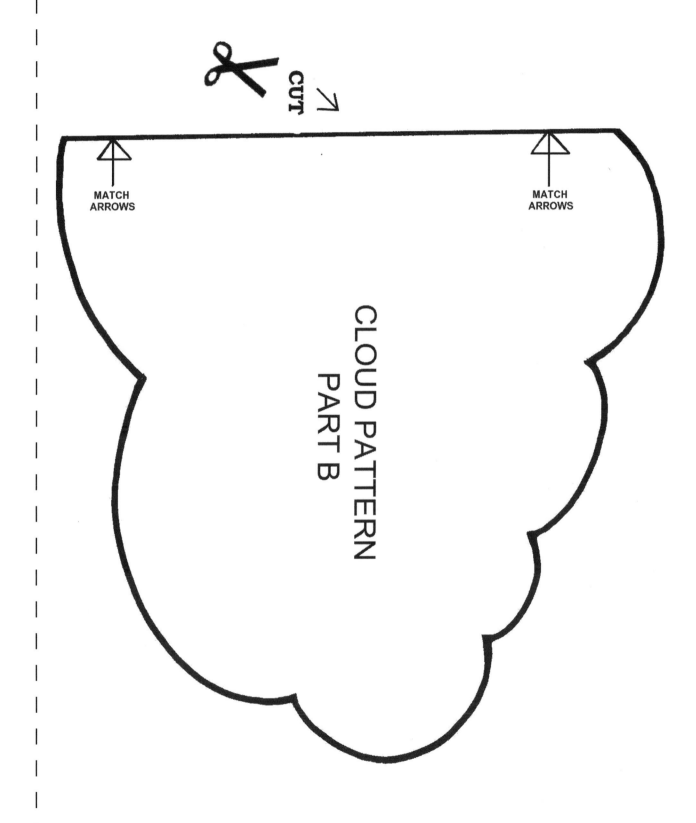

CUT

MATCH
ARROWS

MATCH
ARROWS

CLOUD PATTERN
PART B

BUBBLE LETTER INSTRUCTIONS - CUT THIS PAGE
OUT ALONG DASHED LINE AND MAKE COPIES

STEP 1. Draw a capital letter "A" with a pencil.

STEP 2. Draw an outline all around the outside edge of the "A". Make the outline the same distance from the letter all the way around.

STEP 3. Draw a second outline around the first one to make your letter even fatter.

STEP 4. Draw little circles on the ends at the bottoms and top to make your letter look rounder and puffier. This step is optional!

STEP 5. Draw a thick, dark outline all around the outside edge of the letter. Make your letter look soft and bubbly with no sharp corners or edges.

STEP 6. Erase all of the interior guidelines. You can add small curved lines on the inside of your letter to make it look really puffy.

STEP 1. Draw a capital letter "B" with a pencil.

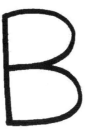

STEP 2. Draw an outline all around the outside edge of the "B". Make the outline the same distance from the letter all the way around.

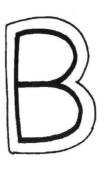

STEP 3. Draw a second outline around the first one to make your letter even fatter.

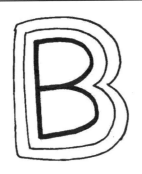

STEP 4. Draw little circles on the sides at the bottom and top to make your letter look rounder and puffier. This step is optional!

STEP 5. Draw a thick, dark outline all around the outside of the letter. Make your letter look soft and bubbly with no sharp corners or edges.

STEP 6. Erase all of the interior guidelines. You can add small curved lines on the inside of your letter to make it look really puffy.

STEP 1. Draw a capital letter "C" with a pencil.

STEP 2. Draw an outline all around the outside of the "C". Make the outline the same distance from the letter all the way around.

STEP 3. Draw a second outline around the first one to make your letter even fatter.

STEP 4. Draw little circles on the ends at the bottom and top to make your letter look rounder and puffier. This step is optional!

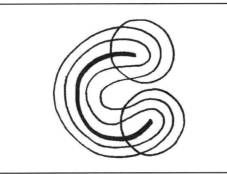

STEP 5. Draw a thick, dark outline all around the outside of the letter. Make your letter look soft and bubbly with no sharp corners or edges.

STEP 6. Erase all of the interior guidelines. You can add small curved lines on the inside of your letter to make it look really puffy.

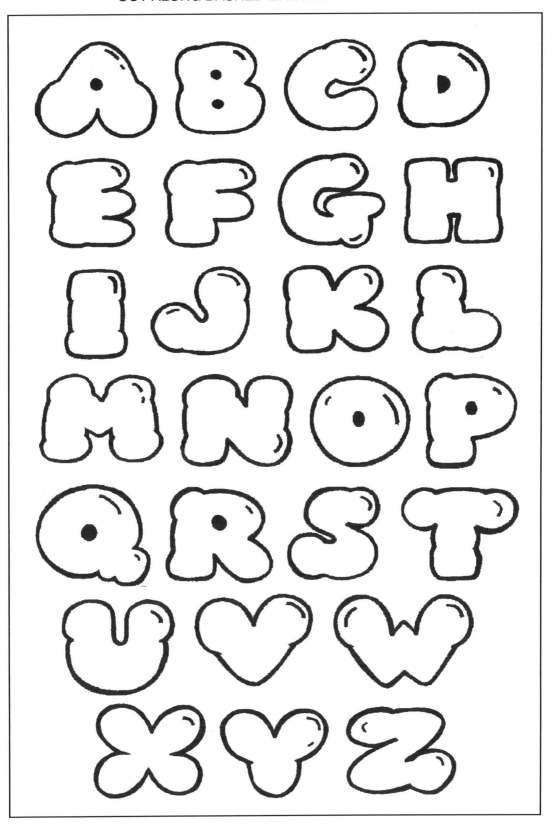

ABOUT US

Graffiti Diplomacy is a Brooklyn based website, art studio and publisher that specializes in graffiti art, multicultural coloring books, and how-to-draw books. We are dedicated to providing beginners and serious graffiti students of any age with graffiti-themed products and instructional materials that are both educational and fun. Now everyone can learn to draw graffiti. Seriously!!!

OTHER TITLES IN THE GRAFFITI DIPLOMACY COLLECTION

"Motivational Mandalas" Graffiti Coloring Book

"OMG!" Another Graffiti Coloring Book of Room Signs

"Moody Monsters" Multilingual Graffiti Coloring Book of Feelings

"Melting Potty NYC" Multicultural Graffiti Coloring Book

"G Is For Graffiti" Alphabet Coloring Book

"G Is For Graffiti" Spanish Alphabet Coloring Book

"Digame Con Colores" Spanish to English Coloring Book

"Because Y's A Crooked Letter" Graffiti Coloring Book of Room Signs

Made in the USA
Las Vegas, NV
14 May 2023